11/69

The Art of the South
1890–2003
The Ogden Museum of Southern Art

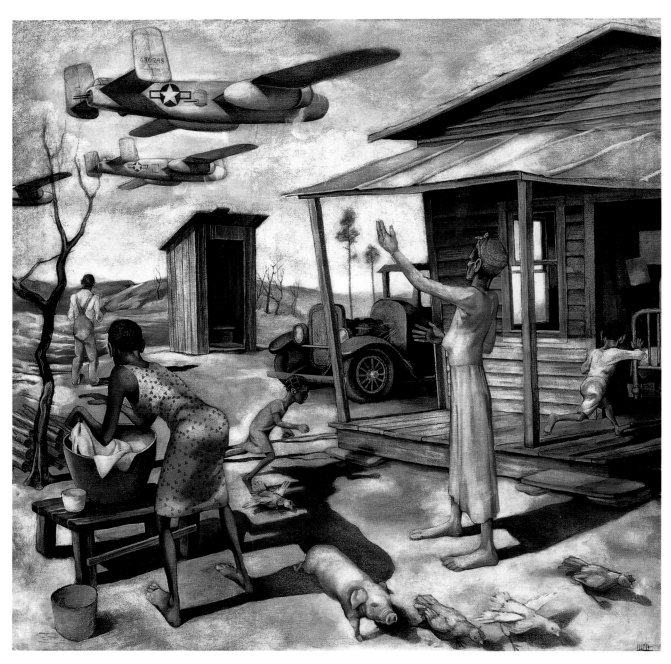

Richard Wilt, *Farewell*, 1943

The Art of the South
1890–2003
The Ogden Museum of Southern Art

J. Richard Gruber and David Houston

O

The Ogden Museum of Southern Art,
University of New Orleans
Goldring–Woldenberg Institute for the Advancement of Southern Art and Culture
In association with Scala Publishers

SCALA

First published in 2004 by
Scala Publishers Ltd
Northburg House
10 Northburg Street
London EC1V 0AT

In association with The Ogden Museum of Southern Art
University of New Orleans
925 Camp Street
New Orleans, LA 70130
USA
www.ogdenmuseum.org

Published in conjunction with the opening exhibition
The Story of the South: Art and Culture, 1890–2003,
August 23, 2003–May 16, 2004

ISBN 1 85759 325 1

Library of Congress Cataloguing-in-Publication Data available upon request

Edited by Annabel Cary
Designed by Andrew Shoolbred Limited
Produced by Scala Publishers Ltd
Printed and bound in Italy by Sfera International, srl

Photographs by Joe Bergeron unless otherwise noted

Contents

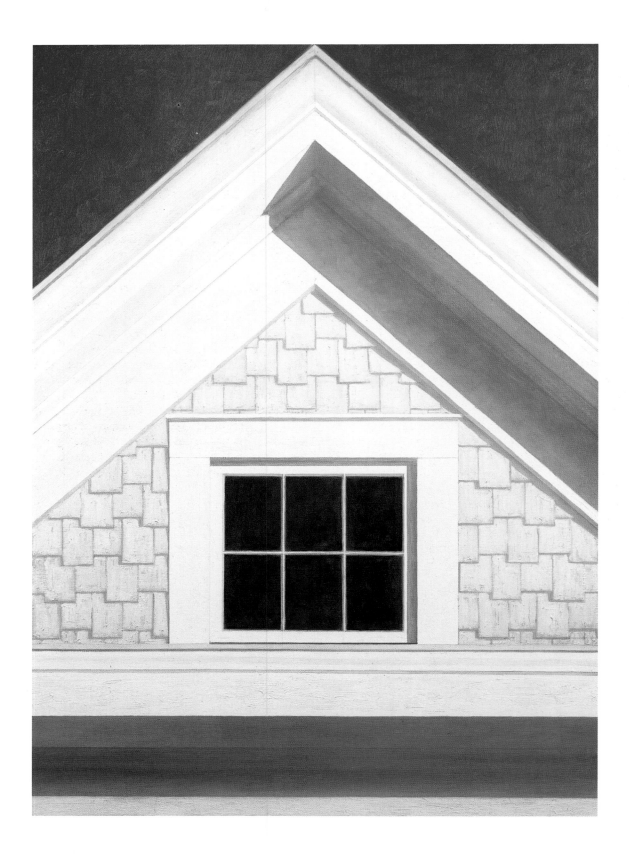

Foreword

The Grand Opening of Stephen Goldring Hall on August 23, 2003 was the culmination of a journey that began over 30 years ago with a single purchase of art as a family gift. Little did Roger Ogden know that this journey would lead to a growing passion for collecting and would result in a nationally recognized collection of Southern art. With this came the realization that the collection needed to be placed in trust for the public—that it must be shared. Thus began the evolution of the vision for a museum of Southern art. Dr. Gregory O'Brien, Chancellor of the University of New Orleans was the first of many to share that vision. He provided leadership, the important academic relationship and a downtown location at Lee Circle so desired by Ogden. The University of New Orleans Foundation, its Board of Directors and the University of New Orleans have been invaluable investors in this public-private partnership from the museum's inception, with Governor Michael J. Foster and the State of Louisiana providing a generous state capital outlay. Fran Villere and Bill Goldring, recruited in 1995 as Capital Campaign Co-Chairs, now serve respectively as Vice-Chair and Chair of the museum's Board of Trustees. Their commitment over the years has been unwavering, and we are grateful for their remarkable support, leadership and generosity. Early and continuing support from the Goldring Family Foundation, with additional support from the Woldenberg Foundation is acknowledged through the dedication of the building to the memory of Goldring's father, and the Goldring–Woldenberg Institute for the Advancement of Southern Art and Culture, which we unveil with this publication. Donors locally and nationwide have made enormous commitments of art and funds to further this shared vision. People across the U.S. have freely given wise advice and counsel. To all of these friends and supporters we are forever indebted.

This book was published in conjunction with the Grand Opening of Stephen Goldring Hall, The Ogden Museum of Southern Art, University of New Orleans, on August 23, 2003 to accompany the exhibition *The Story of the South: Art and Culture, 1890–2003*, presented from August 23, 2003 to May 16, 2004.

It was planned and organized with accompanying catalogue essays by Chief Curator David Houston. Project support was provided by Beverly Sakauye, Associate Director, Jan Katz, Assistant to the Director and Rose Macaluso, Curatorial Assistant, with photographic support by Joe Bergeron.

What began as one individual's private journey has become a journey shared by all those whose extraordinary philanthropy, effort, leadership and partnership have made The Ogden Museum of Southern Art a reality. It is to all these people that we dedicate this book. Now, here in this inaugural catalogue you, the reader, are invited to explore the depth of the Ogden Museum Collection and the Ogden Museum itself, and to begin your own journey through the art and culture of the American South.

J. Richard Gruber, Ph.D.
Director
June 2003

Edward Rice
Gable Window, 1999–2000
Oil on canvas
106.6 × 76.2 cm
Gift of Edward Rice in honor of Freeman and Cora Schoolcraft
© 2000 Edward Rice

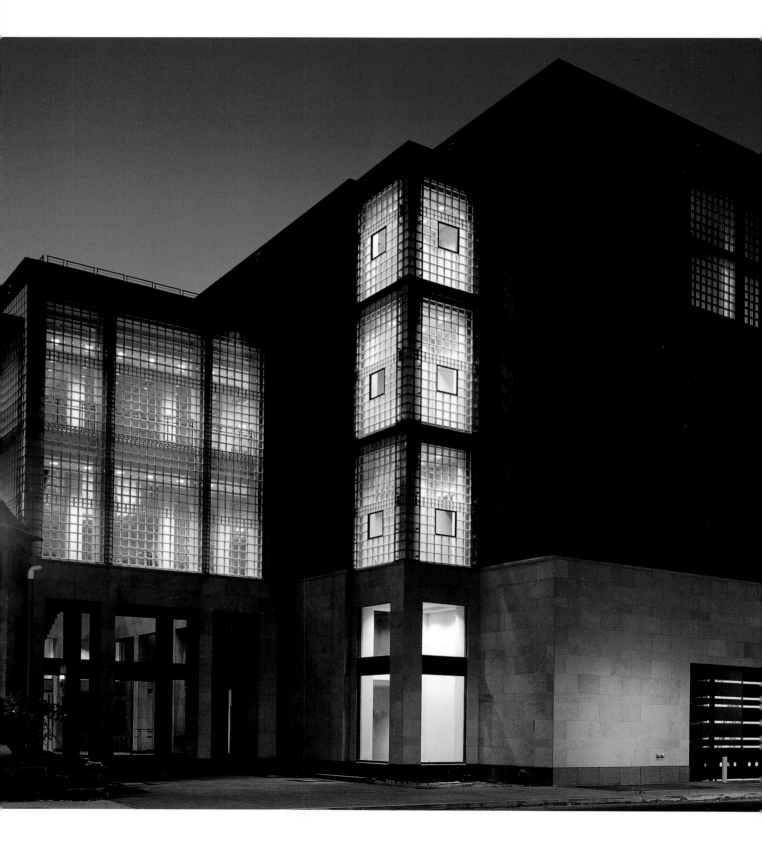

The Story of the South: Art and Culture, 1890–2003

I

The American South is a place known for its rich, complex and often contradictory history. It is a region that has been populated by writers, storytellers and oral historians, many of whom have retold and extended the region's myths and mythology over the years. When asked about the South, many initially think of the 19th century. With an older economic order dependent upon farming and the plantation system (which evolved into a tenant and sharecropper system active into the 20th century), for many the idea of the South remains an isolated reality, a land of dreams marked by classical architecture and gardens shaded by moonlight and magnolias, populated by women in hoop skirts. For others, the South suggests a darker landscape marked by plantations worked by slaves, and a complex racial history related to the Civil War, one that stands, for some, as an emblematic "Lost Cause" and, for others, as a reason to resist old symbols and flags, which glorify that early order.

Until the end of the Depression, the South remained largely a rural region, its slower rhythms broken by the urban culture evident initially in cities like New Orleans, Richmond, Savannah and Charleston, and later in cities like Houston, Dallas, Atlanta and Charlotte. In the years after World War II, a period of dramatic social and cultural change swept across the South. This is reflected in a landscape of oil refineries, NASA operational and launch centers, pioneering research universities and medical centers, computer hardware and software manufacturers, and a growing number of Japanese, German and Korean automotive and truck-manufacturing centers. Beginning in the 1940s, with the growth of military bases, naval yards, air fields and urban manufacturing plants, and expanding when black and white Southern military personnel returned from overseas duty to launch both the civil rights and the postwar Baby-Boom eras of the 1950s and 1960s, the social, economic and political climate of the South continued to evolve in dramatic ways.

During the 1980s and 1990s, the South assumed an increasingly prominent role in the daily life of the nation, as has been noted by many writers and scholars. In 1996, for example, *New York Times* writer Peter Applebome published a book devoted to this subject, *Dixie Rising, How the South Is Shaping American Values, Politics, and Culture*. In his research Applebome discovered fundamental conclusions about the appeal of the region. "Rather than without identity, it's still shaped by the endless sultry summers, voluptuous foliage and wild, romantic excesses of spring colors and summer monsoons that some historians have cited as the most important factors in molding the identity of the South and creating a worldview at odds with its Northern neighbors." He also found other reasons for this national interest in the South. "It offers a sense of history, roots, place and community when the nation desperately is seeking all four. It has a bedrock of belief—religious, cultural, political and racial—that has enormous power and appeal at a time of national drift and confusion."[1]

In addition to this "sense of history, roots, place and community," as Applebome noted, the South is known for its "religious, cultural, political and racial" system of beliefs. Like its history, the musical culture of the South is internationally recognized, and the region is known as the birthplace of jazz, blues, gospel, country, hillbilly, rockabilly and, arguably, rock 'n' roll. It is difficult to imagine 20th-century popular culture without three of the most original and influential of these Southerners—Louis Armstrong, Elvis Presley and James Brown. Even an abbreviated list of other musical legends from the South should include Sidney Bechet, Jelly Roll Morton, W. C. Handy, Bessie Smith, Muddy Waters, Robert Johnson, Leadbelly, Hank Williams, Patsy Cline, Jimmie Rodgers, Gene Autry, Bill Monroe, Loretta Lynn, Mahalia Jackson, Johnny Cash, Little Richard, Carl Perkins, Fats Domino, Jerry Lee Lewis, B. B. King, Clifton Chenier, Ray Charles, Dolly Parton, Otis Redding, Tammy Wynette, Willie Nelson, Ornette Coleman, Dizzy Gillespie and John Coltrane. Also, in the worlds of opera and classical music, noted Southerners include Jessye Norman, Leontyne Price and Van Cliburn.

The region also nurtured William Faulkner and many of the most recognized writers of the 20th century. In addition to Faulkner, one state, Mississippi, produced writers as diverse as Eudora Welty (Jackson), Tennessee Williams (Columbus), Richard Wright (Natchez), Shelby Foote (Greenville), Willie Morris (Yazoo City) and Richard Ford (Jackson). A brief list of

other influential writers from across the South includes Flannery O'Connor, Carson McCullers, Thomas Wolfe, Truman Capote, Lillian Hellman, Walker Percy, Erskine Caldwell, James Agee, John Crowe Ransom, Allen Tate, Robert Penn Warren, James Dickey, Alice Walker and William Styron. In university and literary centers such as Oxford, Chapel Hill and New Orleans, these traditions are continued and advanced by a new generation of writers. And in Oxford and New Orleans annual literary festivals celebrating the lives and works of William Faulkner and Tennessee Williams attract national and international audiences.

Though often perceived to be an isolated region, the 20th-century South evolved to become increasingly tied to the rest of America as new technologies, two world wars and the building of new highway systems brought the nation together. During the 1920s, new recording technologies and popular radio broadcasts brought the musical traditions of the South to regional and national audiences. Hollywood and popular movies of the 1930s and 1940s advanced interest in the South with films like *Gone With the Wind* and, notably, with adaptations of works by Southern writers such as *The Little Foxes* by Lillian Hellman, *Tobacco Road* by Erskine Caldwell, *All The King's Men* by Robert Penn Warren, *Intruder in the Dust* by William Faulkner and, in the 1950s, *The Glass Menagerie* and *A Streetcar Named Desire* by Tennessee Williams. Hollywood films often showcased the talents of popular actors and actresses from the South like Ava Gardner, Joanne Woodward, Butterfly McQueen, Tallulah Bankhead, Patricia Neal, James Earl Jones, Joan Crawford, Sissy Spacek and Morgan Freeman.

Throughout the 20th century, often in subtle yet complex ways, Southern culture became more influential in the wider sphere of American culture, although many remained unaware of the cumulative impact of the region on the nation. Best known for its musical and literary legacies, it is also a region rich in visual culture. However, while the region's traditional architectural and decorative art forms were well known, the broader visual arts of the South remained commonly overlooked. Often, in fact, artists who are highly recognized in New York and other national art centers have strong ties to the South; they include Jasper Johns, Robert Rauschenberg, Sam Gilliam, Cy Twombly, Kenneth Noland and many others.

II

During the 1980s and 1990s there was a new surge of interest in the arts across the South and a growing national interest

in the region's culture, both reflecting unprecedented changes in the region. The oil industry continued to boom in the early 1980s, as did the region's economy, nurtured in part by the growth and relocation of national and international corporations and manufacturers attracted by the aggressive new business culture, as well as by the milder climate and more relaxed lifestyle of the region. Significant population and demographic changes, as noted by Peter Applebome in 1996, were critical to the transformation of the South's established social, cultural and political environment.

Between 1970 and 1990, the population of the eleven states of the Old Confederacy, Virginia, North Carolina, South Carolina, Georgia, Florida, Tennessee, Alabama, Mississippi, Louisiana, Texas and Arkansas, plus Kentucky (a fairly conservative notion of the South), grew by 40 percent—more than 20 million people—twice the national growth rate.... The Census Bureau says that of the ten states that will add the most residents between 1993 and 2020, six are in the South: Texas, Florida, Georgia, North Carolina, Virginia and Tennessee. [2]

The architectural traditions of the South advanced rapidly as international architects like Phillip Johnson, I. M. Pei, Richard Meier, Renzo Piano and Edward Larrabee Barnes, who designed the new skylines of cities like Houston, Dallas, Miami, Atlanta and Charlotte, also designed new art museums, symphony halls and cultural complexes for these cities. [3] In 1983 Dallas and Atlanta opened new art museums in their cities and immediately began to compete at new levels for cultural recognition, drawing national collections, exhibitions and audiences to their cities. Increasingly, as civic and cultural leaders across the South recognized the importance and allure of the arts for business and corporate relocations, and the possibilities for urban revitalization projects, they began to apply higher national standards to the arts of their region, often leading to the rapid transformation of what were once quiet institutions.

During this period, from about 1980 to 1986, as new museum projects blossomed across the South, there was a rush of national and regional research, as well as exhibition and publication activity related to the field of Southern art, which established a sense of momentum that continues to the present day. Some of this interest was nurtured by earlier events such as the widely influential American Bicentennial

celebrations of 1976. In Atlanta, for example, the exhibition *Missing Pieces: Georgia Folk Art, 1770–1976*, presented at the Atlanta History Center, nurtured a new interest in that state's folk art. It also nurtured the idea to open the Judith Alexander Gallery in Atlanta in 1978, dedicated to Georgia and regional self-taught artists, and with a significant focus on the work of artist Nellie Mae Rowe (now featured as an important new artist in the Ogden Museum Collection).

During this time, Roger Houston Ogden, the founder of The Ogden Museum of Southern Art, moved to New Orleans, completed law school at Tulane University and expanded his original vision for a collection of Louisiana art. Now widely recognized as the nation's leading private collection of Southern art, the Ogden Collection began rather modestly in 1966, when Ogden, then a student at Louisiana State University, convinced his father, Roger Hadfield Ogden, to acquire a work by Alexander Drysdale as a present for his mother, Mary Kathryn Schneider Ogden. Over the next decade, the Ogden Collection grew at a modest but steady pace, maintaining its focus on the art of Louisiana. The move to New Orleans was inspiring for Ogden, offering him a greater regional vision and the opportunity to develop a deeper understanding of Southern art and architecture.

During the early years of his professional career, first in law, then in business and real estate development, Ogden traveled extensively, visited art museums and collections, and attended gallery and auction sales. He also became a serious student of the history of Southern art, and carefully monitored the evolving national interest in Southern art. During the 1980s, while his collection was evolving to a more serious level and while national interest in the field was growing, he came to realize that his private collection had the potential to evolve into a museum-quality collection with a focus on the entire South. Increasingly, as he began to think of the collection as a public trust, as a collection that should ultimately reside in a public museum, he became more active and, increasingly, more nationally recognized as a participant and leading collector in this evolving field. In addition to its great value as an art collection based upon a dedicated individual's singular vision, the Ogden Collection is also significant as a permanent reflection of the evolving appreciation and understanding of Southern art, which Ogden has often described in his public lectures as "The Last Frontier of American Art."

By 1976, when the Ogden Collection celebrated the 10th anniversary of its founding, the field of black and white photography had become well established as a viable art medium for museums and private collectors. However, color photography was less recognized in these circles until 1976, when John Szarkowski presented an exhibition of works by a little-known Southern photographer, William Eggleston, at the Museum of Modern Art in New York. This exhibition and the related publication of *William Eggleston's Guide*, also by Szarkowski,[4] propelled Eggleston and his color photographs to the forefront of the art world, though some New York critics and viewers questioned his use of Southern subject matter and his intuitive response to the vernacular and often mundane environment that seemed quite foreign to them. Eggleston, who has been represented in the Ogden Collection for some time, established a pioneering path in the larger world of photography and influenced a generation of photographers, including Maude S. Clay, David Rae Morris, William Greiner and Jack Kotz, all now in the Ogden Museum Collection.

In 1982, the Corcoran Gallery in Washington, D.C., presented an exhibition of works by self-taught artists from the South, *Black Folk Art in America: 1930–1980*, accompanied by a book of the same name by Jane Livingston and John Beardsley.[5] Featured artists included Jesse Aaron, David Butler, Sister Gertrude Morgan and Nellie Mae Rowe, all now in the Ogden Museum Collection. While significant smaller shows had been presented in the South prior to this date, the growing national interest in Southern self-taught artists nurtured by this exhibition is often regarded as a milestone in the folk-art field. The following year, the Corcoran Gallery also presented a large mid-career retrospective exhibition of works by Alabama native William Christenberry, organized by Walter Hopps for the de Menil Museum in Houston. Christenberry, a member of the Corcoran Art School faculty since 1968, is a prominent Southern artist who is well represented in the Ogden Collection and who served, with his extended family, as the subject of an Ogden Museum exhibition, a related publication, *William Christenberry: Art & Family*, and a film by Stanley Staniski, *A House of Many Memories*, in 2000.[6]

In 1983, the Virginia Museum of Fine Arts presented *Painting in the South: 1564–1980*, an important exhibition that traveled to venues across the nation. This extensive survey of Southern painting, accompanied by a catalogue with essays by Jessie Poesch, Carolyn Weekly, Linda Simmons, Rick Stewart and Donald Kuspit, remains a milestone in the development of serious interest in Southern art.[7] Another important survey of Southern art, *The Art of the Old South: Painting, Sculpture,*

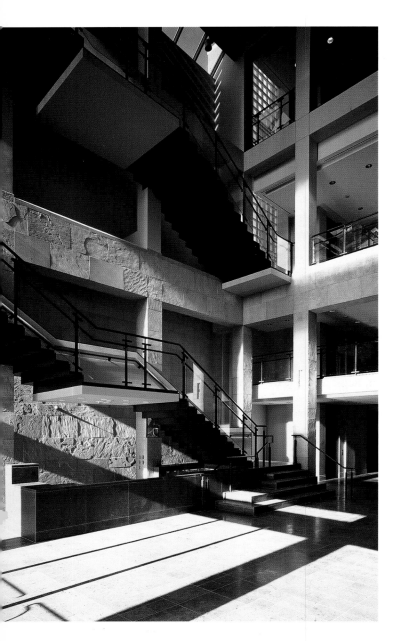

Fig. 2
The Ogden Museum of Southern Art
Stephen Goldring Hall
Atrium
© 2003 Robert S. Brantley

Architecture and the Products of Craftsmen, 1560–1861,
by Jessie Poesch, was also published in 1983.[8] Also, in 1984,
the Columbia Museum of Art, in Columbia, South Carolina,
organized a traveling exhibition titled Art and Artists of the
South: The Robert P. Coggins Collection, accompanied by a
book of the same name written by Bruce W. Chambers.[9]
The national and regional impact of these exhibitions and their
catalogues was significant, establishing a foundation for much
of the work that followed.

Growing institutional interest in the art and culture of the
South also became evident during these years. The Center for
the Study of Southern Folklore, founded in Memphis in 1972,
expanded its programs in the 1980s under the direction of
Judy Peiser. The Center for the Study of Southern Culture,
founded at the University of Mississippi in Oxford, in 1977,
achieved national recognition under the leadership of William
Ferris during the 1980s and 1990s. Its Encyclopedia of
Southern Culture, edited by Ferris and Charles Reagan Wilson,
was published in 1989; it reflected the growing research into
the region's history and culture. That same year, the Center
for Documentary Studies was founded in affiliation with Duke
University in Durham and, in 1992, the Center for the Study of
the American South was founded at the University of North
Carolina in Chapel Hill. Southern art museums devoted exhibi-
tions to prominent regional artists, while some organized
surveys of regional art and culture in projects like Memphis,
1948–1958, presented at Memphis Brooks Museum of Art in
1986.[10] Others, like the Speed Museum of Art in Louisville,
dedicated a gallery to Kentucky art, while the St. John's
Museum of Art in Wilmington expanded its primary focus on
the art and craft of North Carolina.

Some venerable Southern museums, including the Gibbes
Museum of Art in Charleston and the Telfair Academy in
Savannah, placed a renewed emphasis on their permanent
collections of historic Southern art and also concentrated on
the importance of their own institutional histories within the
larger context of the South. On a somewhat different level,
the Greenville County Museum of Art began to collect
Southern art in a serious manner after Thomas Styron became
its director in 1983. The history of this evolving collection has
been documented by curator Martha R. Severens in Greenville
County Museum of Art, The Southern Collection.[11] Regional
galleries, art dealers and auction houses also began to
specialize in Southern art, craft and decorative art, as became
evident at the Robert Hicklin Gallery in Spartanburg (now in

Charleston), the Blue Spiral Gallery in Asheville and Neal Auction Company in New Orleans.

The appreciation of Southern art underwent a major transition in 1992, when the Morris Museum of Art, founded by William S. Morris, III and his family, opened to the public in Augusta, Georgia, as the nation's first museum dedicated to the art of the South. Planning for a Southern art museum took focus in 1989, after William S. Morris met Dr. Robert Powell Coggins in Marietta, Georgia, and purchased the works featured in the exhibition *Art and Artists of the South: The Robert P. Coggins Collection*. Following the death of Dr. Coggins, Morris acquired the Coggins Collection of Women Artists of the South, and a related body of Southern paintings and archival works from the Coggins Trust. In September of 1992, the Morris Museum of Art was opened, forming part of a new complex on the Augusta Riverwalk, which included a new downtown hotel and convention center.

From its opening, the Morris Museum of Art placed a significant focus not only on the collecting and exhibiting of Southern paintings but also upon research and the publication of materials related to its programs. This became evident at the time of its opening with the publication of *A Southern Collection* by Estill Curtis Pennington.[12] The museum opened with a small library and archives within its Center for the Study of Southern Painting (now the Center for the Study of Southern Art), which later expanded into a major research library and archival collection. During its first decade, directed by Keith Claussen, the museum organized exhibitions and publications devoted to Southern artists as diverse as Elliott Daingerfield, William Tylee Ranney, Jasper Johns, George Andrews, Benny Andrews, Ida Kohlmeyer, Robert Rauschenberg and Nellie Mae Rowe. The museum celebrated its 10th anniversary in September of 2002, with Kevin Grogan, its new director, poised to continue its programs on the art of the South.

Smaller museums and art centers dedicated to the lives of individual Southern artists also appeared in these years, as seen with the opening of the Walter Anderson Museum in Ocean Springs, Mississippi, in 1991. Devoted to the life and works of a remarkable Mississippi modernist, the museum brought renewed attention to the accomplishments of the extended Anderson family and its noted Shearwater Pottery. Founded by Peter Anderson in 1928, Shearwater Pottery evolved out of the principles of the Arts and Crafts Movement, absorbed by Annette McConnell Anderson (the mother of the Anderson brothers) during her studies with William and Ellsworth Woodward at Newcomb College. The Ogden Museum has a significant collection of Walter Anderson's works, featured in a gallery dedicated to the artist and his active family.

As these developments took place across the nation, planning for a new museum of Southern art, based upon the collection of Roger Houston Ogden, continued to develop in New Orleans. After its founding in 1966, the Ogden Collection evolved from its primary concentration on the art of Louisiana to become a comprehensive historical survey of the art of the American South. During the 1980s and 1990s, works from the collection were loaned to regional, national and international projects; focused survey exhibitions, such as *Art in the American South, 1733–1989: Selections From The Roger Houston Ogden Collection*, were made available to curators for exhibitions in Louisiana and in locations that included Washington, Oakland, Nashville, Charleston, Columbia, Mobile, Pensacola and Athens.[13] Major works from the collection were also exhibited in the Vatican and at the American Embassy in Brunei.

The public announcement of the founding of The Ogden Museum of Southern Art was made in December of 1994 by Roger Ogden and Dr. Gregory O'Brien, Chancellor of the University of New Orleans. The concept for creating a permanent public home for the Ogden Collection was based upon a unique public-private partnership. It was built upon a gift of works from the Ogden Collection to the University of New Orleans Foundation to establish a museum of Southern art, which would be constructed in a complex of buildings in the Lee Circle area of the city. Two years later, in 1996, Randolph Delehanty, then director of the museum, published a major volume titled *Art in the American South: Works from the Ogden Collection*, which would bring his research on the collection to larger audiences.[14] By 1999, the museum's five-story Stephen Goldring Hall was under construction and its historic library was under restoration. In October of that year, a new museum professional staff opened a transitional museum space in a Julia Street gallery, located nearby in the Warehouse Arts District. On Julia Street, the staff organized and presented more than 25 exhibitions drawn from the Ogden Collection as well as from the growing number of collections and individual works donated by artists, collectors and art foundations from across the United States.

Fig. 3
Louis Armstrong
Taineishia Lefort

Educational and public outreach programs were presented on Julia Street as well as in diverse schools and neighborhoods across the city, while the staff also continued to advance the museum's teaching, research and publication activities. Working with the concept of a "museum without walls" to reach non-art and non-traditional audiences in the community, the museum initiated new programs such as "Artists and A Sense of Place." Supported by grants from State Representative Karen Carter and the Louisiana Stadium and Exposition District fund, this project encouraged living artists in the museum's collection to work with students and schools in their neighborhoods, including the historic Tremé and Central City areas, to develop creative projects using those neighborhoods as inspiration for the students and their teachers. Featured artists have included Jeffrey Cook, Elizabeth Shannon, José Torres Tama and Gina Phillips. These New Orleans community arts concepts were recently expanded in a new partnership with St. Mark's Community Center to open the UpHill Gallery in the Tremé area near the French Quarter, a district that, historically, has served as home to many of the city's important musicians.

The opening in 2003 of a permanent home for The Ogden Museum of Southern Art in New Orleans is more than merely a reflection of the historical and contemporary vibrancy of the arts scene in this city. In many ways, the opening of the Ogden Museum serves as a notable evolutionary step in the nation's growing interest in the art and material culture of the South. Housed in Stephen Goldring Hall, designed by the New Orleans firm of Barron & Toups, with Concordia Architects, the opening of the museum was structured around a survey collection of paintings, prints, sculpture, photography, craft and design, all of which reflect the evolution of Southern art from 1890 to 2003.

Goldring Hall stands as part of a larger, three-building complex that includes a significant 1889 library designed by the important American architect and Louisiana native, Henry Hobson Richardson. The only one of Richardson's buildings in the South, the library will house the museum's 18th- and 19th-century art collections, its new Goldring–Woldenberg Institute for the Advancement of Southern Art and Culture, an orientation theater, studio and classroom spaces, and a technology resource center. Programs related to the architecture and the life of H. H. Richardson will be an integral part of the activities presented in this structure. It will be adjoined by the new Clementine Hunter Education Wing, dedicated to the art and life of this noted Louisiana self-taught artist, and will contain educational, docent program and gallery spaces dedicated to 19th- and early 20th-century art.

III

Similar to the geographic definition of the South used by the Center for the Study of Southern Culture in Oxford, the Roger Houston Ogden Collection and The Ogden Museum of Southern Art define the South to include the District of Columbia, Maryland, West Virginia, Virginia, Kentucky, Tennessee, North Carolina, South Carolina, Georgia, Florida, Alabama, Mississippi, Louisiana, Texas, Arkansas and Oklahoma. Although their geographic guidelines delineate a slightly smaller South, the Morris Museum of Art and the Greenville County Museum of Art seem to share the Ogden Museum's response to the common question: "What is Southern art?" Essentially, the Ogden Museum defines Southern art to include work created by artists born in the South, artists active in the South, artists creating work depicting Southern subjects or themes, as well as foreign artists who were (or are) active in the region, or who depict Southern subjects or themes. Additionally, the Ogden Museum includes a category for Southerners abroad, devoted to the work of Southern artists who were (and are) active in other countries.

The museum's opening exhibition, reflecting the range of the research and acquisition programs that directed the development of the Roger Ogden Collection and the expansion of The Ogden Museum of Southern Art collection in recent years, is titled *The Story of the South: Art and Culture, 1890–2003*. The opening installations in Goldring Hall have been arranged

in a chronological and thematic manner, tracing the evolution of the art and the history of the South in these years. In addition, a series of original films and multi-media gallery installations, created over a period of several years by Washington, D.C., filmmaker Stanley Staniski, have been supported by the Goldring–Woldenberg Institute and are featured in the opening installations. In the script for his museum orientation film, completed after extensive research and travel through the South, Staniski builds upon the museum's growing focus on "The Art of Family" to explore themes of "Community," "History and Memory" and "Celebration and Spirit" in the art and life of the South.

Following the era of the Civil War and Reconstruction, the South lagged behind other regions in dedicating public structures like art museums, symphony halls and libraries. While art museums in New York, Boston, Philadelphia and Chicago opened at a steady pace in the 1880s and 1890s, museums remained less common in the South. For the purposes of this study, this period essentially began with the arrival of William and Ellsworth Woodward in New Orleans, in 1884 and 1885 respectively (see timeline). Both brothers were trained at the Rhode Island School of Design in Providence, where they absorbed the lessons of the international Arts and Crafts Movement—lessons they would share with their many Newcomb and Tulane students. During this period, the Louisiana Cotton Exposition of 1884 was presented in Uptown New Orleans, near the Tulane campus. Similar expositions were organized in other Southern cities including Louisville, Atlanta and Nashville, all reflecting a growing desire to position these urban centers as models of the "New South," a progressive idea advanced by journalist Henry Grady in Atlanta.

The Ogden's exhibition begins with a gallery devoted to Impressionist, Tonalist and landscape paintings, with selected works by William Woodward, Lulu King Saxon, Julian Onderdonk, Alexander Drysdale, Alice Ravenel Huger Smith, William Posey Silva and others (see accompanying catalogue essays by David Houston). The exhibition continues with a focused survey of landscape painting by Clarence Millet and others through mid-century, reflecting the region's continuing interest in traditional styles and techniques, while still maintaining old attitudes toward the natural world. These would be increasingly challenged by the oil exploration, mining, lumbering and manufacturing activities that were evident as the century advanced toward the years of World War II.

Much of the South remained rural and far from cosmopoli-

tan well into the middle of the 20th century, yet certain cities, including New Orleans and Charleston, served as Southern musical, literary and artistic centers. In New Orleans, Louis Armstrong, Sydney Bechet and other notable musicians were nurtured; they absorbed the city's rhythms and established the foundations of modern jazz. Artists and writers were attracted to the French Quarter's Bohemian environment during the 1920s and 1930s. When Sherwood Anderson arrived in New Orleans in 1922, the noted literary magazine *The Double Dealer* was already being published in the city. From 1922 to 1925, Anderson lived and worked in the Upper Pontalba building overlooking Jackson Square, where he hosted literary events for notable figures, including the young William Faulkner and Edna St. Vincent Millay. Artists like Jules Pascin (who sketched details of life in the city during this era) and Knute Heldner (particularly in his painting *French Quarter Roof Tops from his Studio*) sought to capture the architecture, people and spirit of a distinctive place. During his first year in New Orleans, Sherwood Anderson published an essay describing his impressions of the Bohemian spirit of the city many regarded as the "Paris of America."

I proclaim myself an American and one of the Moderns. At the present moment I am living in New Orleans, I have a room in the "Vieux Carre" with long French windows, through which one can step out upon a gallery, as wide as the street below. It is charming to walk there, above the street and to look down at others hustling off to work. I do not love work too much. Often I want to loaf and I want others to loaf with me, talk of themselves and their lives…. I sit in my room writing until the world of my imagination fades. Then I go out to walk on my gallery or take my stick and go walk in the streets…. There is an old city here, on the lip of America, as it were, and all about it has been built a new and more modern city. In the old city a people once lived who loved to play, who made love in the moonlight, who walked under trees, gambled with death in the dueling field.[15]

Will Henry Stevens, one of the South's most important modernists, came to New Orleans to teach at Newcomb College in 1921, and became a quiet but significant presence in the city's progressive art world until his retirement in 1948. Prior to moving to New Orleans, he worked in Louisville and along the Ohio River Valley near his home town of Vevay, Indiana. Trained in the principles of the Arts and Crafts Movement,

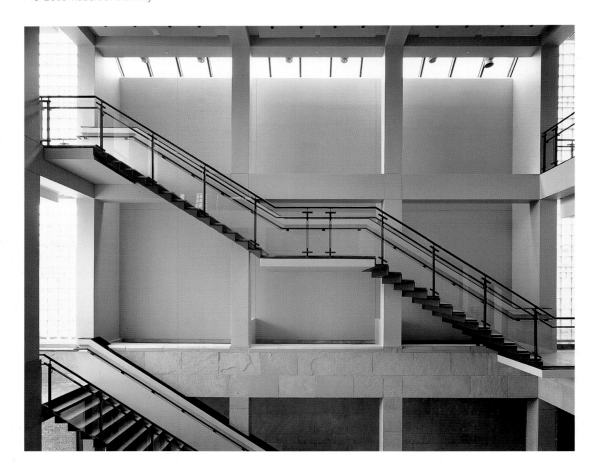

immersed in the theories and works of Kandinsky, a regular visitor to the galleries and museums of New York and Washington, D.C., Stevens was a sophisticated artist with a unique vision. As the permanently dedicated gallery named in his honor may suggest, the Ogden Museum has become the nation's leading public repository of the works and archival materials of this significant artist. In two works from this collection, *Mountain Landscape with Lake* and *Blue Background with Multicolored Circles*, we see evidence of the artist's

dedication to the creation of naturalistic, almost American Scene imagery, even when he explored his most abstract and non-objective imagery in the later years of his career.

In the years after World War I, writer Thomas Craven and artist Thomas Hart Benton campaigned for new American art forms that rejected foreign influences and subject matter. Described as the American Scene Movement in the 1920s, then evolving into what the art and popular press of the day called "Regionalism," the art of this era often focused on the

realities of daily life on a local level, as seen in the works of Benton, John Steuart Curry and Grant Wood during the 1930s. Benton, whose family had strong historical and cultural ties to the South, embarked on extended sketching trips through the South in the 1920s and early 1930s, regularly returning to New York to use his Southern experiences as inspiration for many of his most important early paintings and mural projects. Also, as demonstrated in his published writings, he appreciated and understood the complex and contradictory nature of the South.

Who knows the South? It is a land of beauty and horror, of cultivation and refinement, laid over misery and degradation. It is a land of tremendous contradictions … the South remains our romantic land. It remains so because it is. I have seen the red clay of Georgia reveal its color in the dawn, and the bayous of Louisiana glitter in magnolia-scented moonlight. There are no crude facts about the South which can ever kill the romantic effect of these on my imagination.[16]

As one of the nation's most important artists and as an influential teacher at the Art Students League in New York, Benton's works and philosophies were central to the spirit of the American art world during the Depression era. A number of his students at the League came from the South, including John McCrady, who later returned to his native state of Mississippi, then moved to the French Quarter, where he opened his own art school. A work like *The Parade* by McCrady, from the Ogden Collection, shows his training with Benton, yet it also reflects his unique vision and understanding of the life and culture of the French Quarter and Mardi Gras. Others in the South showed awareness of these trends, though they were not slavishly bound to the theories of New York. Marie Hull, active in Mississippi and recognized as an artist and teacher, was well known for images such as her *Tenant Farmer*. During the war years, where he spent time in Greenville, South Carolina, Richard Wilt painted *Farewell* (or *Low Altitude Formation*), a work depicting the passing of the rural agricultural order, which stood in contrast to the new social realities of the war years in the South.

Far removed from these concerns, a small group of avant-garde artists were drawn to Black Mountain College in North Carolina. Outside of Asheville, the school founded by Andrew Rice in 1933 attracted future American art leaders who studied under the transplanted German artists Josef and Anni Albers,

who imported European principles and techniques to the mountains of the South. Here, in the years from 1946 to 1951, the faculty and students included figures as diverse as Jacob Lawrence, Beaumont Newhall, Walter Gropius, John Cage, Willem de Kooning, Buckminster Fuller, Kenneth Snelson, Kenneth Noland, Harry Callahan, Robert Rauschenberg, Franz Kline and Jack Tworkov. After absorbing the progressive and interdisciplinary lessons of Black Mountain, these artists often shuttled between North Carolina and New York, carrying emerging visions in both directions.[17]

Photography was an important part of the Black Mountain program, one particularly appealing to Robert Rauschenberg, originally from Port Arthur, Texas, who was strongly influenced by his experiences at the school. Photography, a major focus in the collections of the Ogden Museum, has been an essential art form in the South from its earliest period; it emerged as a major documentary form before establishing its importance in recording the realities of the Civil War. By the early 20th century, photography was a well-accepted medium in the South. Photographers as diverse as Ernest James Bellocq, Clarence John Laughlin and Henri Cartier-Bresson (all featured in the Ogden Collection) were active in the region and created some of the most memorable images of the South.

With the coming of the Farm Security Administration (FSA) and the federal art programs of the Depression era, the South became even more actively photographed. Figures like Russell Lee, Dorothea Lange, Ben Shahn and Walker Evans were active in the region, capturing unforgettable subjects during a transitional era in the South. Active on a regional level in Louisiana and Mississippi, photographers Theodore Fonville Winans, Elemore Morgan, Sr., and Eudora Welty are all well represented in the Ogden Collection. Welty, best known as a writer from Mississippi, produced photographs of the life and manners of her state during the 1930s. The diverse programs of the Works Progress Administration (WPA) served as catalysts to the development of the Southern art world and helped create a greater sense of artistic community in the region. The WPA was a major influence in the arts and architecture, as evident in the federal building projects that include museums, libraries, schools, auditorium spaces and other civic structures that were long overdue in the South. The Woodward brothers were active in the Gulf Coast WPA, as was the artist Walter Anderson, who created murals depicting the early and modern history of the Gulf Coast for Ocean Springs High School (now in the Anderson Museum in Ocean Springs).

Fig. 5
The Ogden Museum of Southern Art, 2001
Architect's rendering
Errol Barron

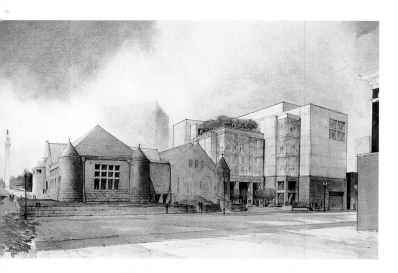

In the years following World War II, from 1945 to 1975, the South entered a time of dynamic transition. It was a period of emergence from the Depression and war years to a new economic boom, an era marked by the Baby Boom, the move from cities to the suburbs, the appearance of the GI Bill and the related growth of universities and university art departments, the era of the Civil Rights movement, the beginnings of the television age, the jet age and the space age, as well as the emergence of the Black Power and feminist movements during the 1960s and 1970s. This was also a period when the earlier tides of migration away from the South began to be reversed, when many people began to move to the South, to the emerging "Sunbelt" regions of the South and Southwest, and when populations and demographics shifted in radical ways, forever altering the face of politics and life in the once segregated South.

After the war, another wave of creative Southerners left the region and moved to more established urban art centers like New York, Chicago, Washington, D.C., and Philadelphia, where veterans often used their GI Bill benefits to advance their educations. Others went to the West Coast, to cities like Los Angeles and San Francisco. Willie Morris, a native of Mississippi who was influential in New York literary circles, described the attraction of New York in his important book *North Toward Home*. For many artists, the emergence of Abstract Expressionism and the evolution of New York as the world's art capital became an increasingly alluring attraction. Southern-born artists like Jasper Johns, Robert Rauschenberg, Cy Twombly, Fritz Bultman and others became influential figures in this environment. Conversely, the influence of the New York School became an increasing reality in the South, at times in a literal way when figures like David Smith, Mark Rothko, Clifford Still and others traveled to teach there. During the 1950s, Abstract Expressionism became the official art tradition of art departments across the South, as was evident to the young William Christenberry when he studied at the University of Alabama in Tuscaloosa from 1954 to 1959.

The emergence of the Civil Rights movement in the South reflected the deep nature of social change in the area after the war years, and marked the beginning of the end of the era of "separate but equal," instituted after the Plessy v. Fergusen decision in 1896. The process was slow and evolutionary, as seen with the passage of the Brown v. Board of Education of Topeka decision in 1954, the efforts of individuals including Rosa Parks, Martin Luther King, Jr., numerous slain and injured civil rights workers, and countless others. The nation, and the nation's media, followed these events closely, documenting a changing South in powerful print images and in television footage that is still etched on the nation's collective memory. These social and historical events made a deep impact upon the nation's creative community as well. Photographers such as Ernest Withers and Charles Moore recorded critical moments and events during these years. Responding to prominent events in the South from New York, Andy Warhol incorporated media images of the Birmingham police attacks on crowds into a powerful series of works completed in 1963. The passage of the Civil Rights Act of 1964, followed by the Voting Rights Act of 1965, marked a final end to an old era in the South.

Benny Andrews—born into a sharecropper family in Depression-era Georgia and the son of a self-taught artist—embodied many of the issues evident in this era of the South's history. Denied admission to the noted art school at the University of Georgia because of his mixed-race heritage, he

returned from service in the Korean War and used his GI Bill benefits to study painting at the school of the Art Institute of Chicago, from 1954 to 1958. After moving to New York in 1958, he began to combine the techniques of Abstract Expressionism with his personal collage aesthetic to create distinctive American forms. By 1965, as seen in his *Death of the Crow*, he had developed his own style and used it to respond, in a subtle yet moving way, to matters such as the passing of the Voting Rights Act of 1965 and the related death of the "Jim Crow" South, which had overshadowed his life. Later, as seen in the large collection of works the artist and his family have donated to the Ogden Museum, he created an ongoing series of works that extended his acute observations and reflections upon the changing nature of life in America and the South.

The new interest in folk and self-taught artists during the 1980s brought national attention to the region after the Corcoran exhibition of 1982. Curators, scholars and collectors began to roam the back roads of the South in search of established and undiscovered folk-art masters. Historic and contemporary figures like Nellie Mae Rowe, Clementine Hunter, Bill Traylor, Mose Tolliver, Sam Doyle and William Edmondson achieved growing recognition. Howard Finster and his quirky art forms quickly rose to national celebrity from his rural location in Georgia during the 1980s and 1990s, while artists like Thornton Dial from Alabama received new attention, including a major museum exhibition in New York. Others, like Bessie Harvey in Tennessee, Lonnie Holley in Alabama, and Sister Gertrude Morgan in New Orleans, worked and rose to increasing national prominence, as evident in the range of their works featured in the Ogden Museum Collection.

New and traditional craft traditions emerged as an important regional and national force during the 1970s and 1980s. Penland School, Arrowmont, Berea College, the Hambidge Center and other crafts schools in the South achieved new levels of interest and professional stature. Early in the century, these schools, like Newcomb College, offered practical training and ways to make a living as an artist, skills that were still applicable in the contemporary era. Artists including Richard Jolley, Robyn Horn, Mitchell Gaudet, Dan Finch, Stoney Lamar, Gene Koss and others continued and advanced these traditions, as seen in the Ogden Museum collections and galleries. These artists expanded upon the craft traditions developed at Newcomb in the early 20th century, and also looked back with appreciation to the expressive and pioneering efforts of

George Ohr, long active in Biloxi, Mississippi. With a figure like Ohr active in clay from an early date, the line between art and craft was often a thin or arbitrary one in the South. When a new generation of artists emerged during the 1960s, 1970s and 1980s, who commonly sought new directions and attitudes toward "craft" materials and their relationship to the traditions of "fine art," they only had to look back to the history of these traditions in their own region.

The works created by Southern artists since 1976 are quite diverse in techniques and technologies, in materials and in the artists' complex approaches to questions relating to the use of realism versus abstraction or non-objective subject matter. Many of these issues, of course, as David Houston indicates in his essays, continue the explorations initiated much earlier in the century. Some Southern artists—including those active in the Black Emergency Cultural Coalition, co-founded by Benny Andrews in his New York studio—began to march before museums such as the Metropolitan Museum of Art and the Whitney Museum of Art, protesting against those institutions' lack of responsiveness to the works of women and artists of color in their collecting and exhibition programs. And, interestingly, just as the South developed more significant museums, galleries and exhibition spaces, some artists began to work on a scale and ambition that transcended the limitations of the museum and gallery environment.

During the 1980s and 1990s, as previously suggested, the South entered what may have been its most profound period of development and transformation. New residents, with new businesses and new technologies, as well as new immigrant populations with new cultures, brought radical and seemingly instantaneous change to a region that has long resisted change. Art, music and literature reflect these changes in diverse ways across the South. At certain times, as during the 1996 Olympic Games in Atlanta, the region seemed prepared to pause, study and reflect upon these transformations in featured exhibitions such as *Souls Grown Deep, African American Vernacular Art of the South*, curated by William Arnett, and in other performances and special projects. But soon after, life returned to its usual intensifying pace and reflection is forced to await another official event or ceremony. The South has become too busy, too hyper-animated to sit on the metaphoric front porch and meditate over such matters— a sign of change in itself.

In the works now on view at The Ogden Museum of Southern Art and in studios, galleries and museums across the

region, we find the continuation of established traditions in the South and, equally, a willingness to face and confront new realities, new technologies and new challenges evident in the larger environment. This is evident in many different ways in works by artists as diverse as Elemore Morgan, Jr., Douglas Bourgeois, Ida Kohlmeyer, William Dunlap, Willie Birch, Alexander Stolin, Arless Day, William Moreland, Edward Rice, Vincencia Blount, Kendall Shaw, Jesús Moroles, Keith Sonnier, Nene Humphrey, Tom Rankin, Maude S. Clay, Jack Spencer, Birney Imes, Jack Kotz, David Rae Morris, William Greiner, Stoney Lamar, Richard Jolley, Robyn Horn, Mitchell Gaudet, Benny Andrews, William Christenberry, George Andrews, Thornton Dial, Bessie Harvey, Herbert Singleton and many others.

Southern culture, while still distinctive in many ways, has increasingly become a larger and more important part of American culture in recent decades. This larger national connection was made quite clear, to all Americans, on September 11, 2001. And, as the realities began to settle in, it became evident that many artists sought ways to respond to the events of that day. Accordingly, the Ogden Museum organized an exhibition of diverse works by artists, titled *Then and Now, 1941–2001*, which addressed, in many different ways, the thoughts and emotions borne by these artists. Christopher Saucedo, a sculptor and member of the University of New Orleans Fine Arts department faculty, created an incredibly moving piece in honor of his brother, a New York City fireman, who was lost in a building he and his brothers had, literally, grown up with in New York. This piece incorporated a childhood photograph of the two older Saucedo brothers posing at the World Trade Center construction site months before the youngest Saucedo brother Greg was born, bracketed by a more recent photograph taken at the ruined site, missing the now deceased brother. Between the photographs, marking the passage of time and a specific life, a piece of twisted and charred steel from the World Trade Center site was mounted on a custom shelf made by the artist. This deeply moving work is now included in the permanent collection of The Ogden Museum of Southern Art.

IV

For more than three decades, while studying Southern art history and considering the long-term significance of his collecting activities, Roger Ogden has come to regard the art of the South as "The Last Frontier of American Art." Increasingly, over the past decade, in the public talks he has presented across the region and the United States—to groups of all sizes and all levels of sophistication—he has described Southern art in terms of this "Last Frontier." Then, in 1996, when Randolph Delehanty published his volume on the Ogden Collection, he echoed these ideas and this philosophy in his essay *The South: The Last Frontier in American Art*. Throughout the 1990s to the present day, it is still possible to discover those who have little or no comprehension of the importance and range of the art and artists of the South. In that sense, and with that in mind, the concept of the "Last Frontier" is still viable.

However, it now appears, at least to this observer, who has been an active participant in the field of Southern art for more than 20 years that the "Frontier era" of Southern art may be coming to a close. Accordingly, a new era in Southern art may be dawning. Now, it seems, is the time for the next stage in the evolution of Southern art, building upon the dedicated work of so many over the past two decades and moving to a new level of regional and national recognition, and understanding. Now is the time to recognize the importance of Southern art, and how it reflects the complex culture and history of the South. Now is the time to advance and expand existing efforts to integrate the best of the South with the best of the national and international art world. This should not be a provincial effort, but it should be one rooted in place and in the *spirit* of place. It should recognize the work of those who have come before and continue to work in this field, building upon their research, exhibitions and publications. It should recognize the evolutionary character of the field and the importance of the diverse programs, projects and museums involved over the past two decades. It should be an effort that seeks to integrate, as appropriate, pioneers in the field of Southern art and culture into the large field of American art and culture, while still affirming the unique qualities of the region and its culture. Musicians like Louis Armstrong, Elvis Presley and James Brown, deeply rooted in the soils and culture of the South, were (and are) more than provincial or regional artists, just as William Faulkner, Eudora Welty and Thomas Wolfe were more than "Southern" writers.

The South today is, undeniably, part of the larger world. This is no more evident than in the emergence of Southern cuisine, which began in the late 1970s and 1980s. In addition to the popularity of Cajun and Creole foods today, many of the nation's leading celebrity chefs are now from the South, including Emeril Lagasse, Susan Spicer, Scott Peacock and Paul

Prudhomme among others. Across the South, at university symposia, in countless essays and academic debates, the meanings and implications of changes in the contemporary South are explored and documented. While the debates and discussions take place, the rate of change expands. Evidence of the South's place can be seen in the presence of CNN's world headquarters in Atlanta, the presence of computer hardware and software plants in Texas, the recent opening of a massive new Nissan plant near Jackson, Mississippi, and in the growing popularity of cell phones, wireless laptop computers, Palm Pilots, digital cameras and diverse other new technologies. We live in a South that is connected, wired and wireless, linked and hyperlinked. It is an urban world surrounded by suburban sprawl, shopping centers, gated communities and traffic congestion. Where Southerners once drove "American" cars and trucks, they now drive vehicles made in the South by Honda, Toyota, Mercedes, Saturn, Nissan, BMW and other international corporations. It is, in short, a complex new world in the South.

Yet still, across the region, there is a world tied to the past, a world that is conservative and conserving, filled with preservationists and die-hards. In some parts of the South, 18th- and 19th-century architectural centers survive, as in New Orleans, Charleston, Savannah, Beaufort, Oxford and Natchez. They remain while cities like Miami, Dallas, Houston, Atlanta and Charlotte have built towering new symbols of the South in the 20th and 21st centuries. And, while preservation societies maintain and restore historic structures and gardens across the region, contemporary architects and clients plan monuments for a new generation.

The South has evolved dramatically over the past 20 years. Now, in the early 21st century, museums like the Ogden Museum will exist to preserve and explore the South and its culture. We will study and document these matters through the activities of the Goldring–Woldenberg Institute for the Advancement of Southern Art and Culture, a new branch of the museum that will be devoted to progressive public programs, research, publications, oral history projects, the creation of films and documentaries, educational outreach programs and new uses for advancing technology as a means to share these programs with larger national and international audiences. Some might say that one frontier has ended and another has begun, not unlike that familiar "New Frontier" of the 1960s. Long the dream of Roger Ogden, one shared by Bill Goldring, Greg O'Brien, Fran Villere and others who have worked diligently for this project, the opening of The Ogden Museum of Southern Art, University of New Orleans, in the Warehouse Arts District of New Orleans, is a significant evolutionary step in the advancement of Southern art and culture.

J. Richard Gruber, Ph.D.

1 Peter Applebome, *Dixie Rising: How the South is Shaping American Values, Politics and Culture* (New York: Times Books, 1996), 14, 21. See also Dewey W. Grantham, *The South in Modern America: A Region At Odds* (New York: Harper Perennial, 1994); James C. Cobb, *Redefining Southern Culture: Mind and Identity in the Modern South* (Athens: The University of Georgia Press, 1999) and Pete Daniel, *Lost Revolutions: The South in the 1950s* (Chapel Hill: The University of North Carolina Press, 2000).

2 *Ibid.*, 8.

3 See Douglas Davis, *The Museum Transformed: Design and Culture in the Post-Pompidou Age* (New York: Abbeville Press, 1990), 60–75, 124–129.

4 John Szarkowski, *William Eggleston's Guide* (New York: Museum of Modern Art, 1976).

5 Jane Livingston and John Beardsley, *Black Folk Art in America: 1930–1980* (Jackson: University Press of Mississippi, 1982).

6 J. Richard Gruber, *William Christenberry: Art & Family* (New Orleans: University of New Orleans Publishing, 2000).

7 David S. Bundy, editor, *Painting in the South: 1564–1980* (Richmond: Virginia Museum, 1983).

8 Jessie Poesch, *The Art of the Old South: Painting, Sculpture, Architecture and the Products of Craftsmen, 1560–1861* (New York: Harrison House, 1983).

9 Bruce W. Chambers, *Art and Artists of the South: The Robert P. Coggins Collection* (Columbia: University of South Carolina Press, 1984).

10 J. Richard Gruber, *Memphis: 1948–1958* (Memphis: Memphis Brooks Museum of Art, 1986).

11 Martha R. Severens, *Greenville County Museum of Art: The Southern Collection* (New York: Hudson Hills Press, 1996).

12 Estill Curtis Pennington, *A Southern Collection* (Augusta: Morris Museum of Art, 1992).

13 Herman Mhire, editor, *Art in the American South, 1733–1989: Selections from the Roger Houston Ogden Collection* (Lafayette: University Art Museum, University of Southwestern Louisiana, 1993).

14 Randolph Delehanty, *Art in the American South: Works from the Ogden Collection* (Baton Rouge: Louisiana State University Press, 1996).

15 Sherwood Anderson, *New Orleans, the Double Dealer and the Modern Movement in America*, published in Judy Long, editor, *Literary New Orleans* (Athens: Hill Street Press, 1999), 85–86.

16 Thomas Hart Benton, *Thomas Hart Benton, An Artist in America*, 4th rev. ed. (Columbia: University of Missouri Press, 1983), 198. For additional information on Benton's significant ties to the South and its culture, see J. Richard Gruber, *Thomas Hart Benton and The American South* (Augusta: Morris Museum of Art, 1998).

17 See Mary Emma Harris, *The Arts at Black Mountain College* (Cambridge: The MIT Press, 1987).

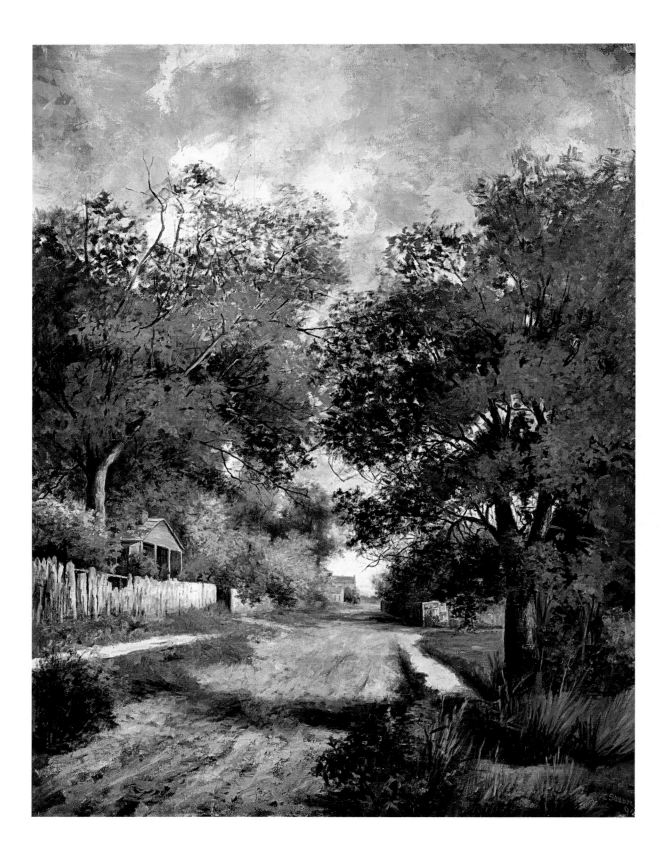

1 | Landscape

Southern art, while closely linked to many important trends in American art, follows a different logic and unfolds at a pace of its own. Most historians interpret the history of art as a series of successive styles and movements with one superceding the other. The art of the South, grounded in its own complex and often troubled history, unfolds in a non-linear, circuitous path that challenges the historian and viewer alike. This folding and bending of styles and movements across place and time often yields unforeseen results, which sometimes anticipate important national developments, and often retain or revisit subjects and approaches after they have elsewhere receded into the chapters of history.

The importance of place is one of the defining concepts of Southern art. The importance of the land, both real and mythic, is a dominant theme in Southern art, music and literature. Not only has Southern landscape painting persisted, but it has flourished when landscape was largely overlooked as an important subject in other regions. The dramatic topographies of the South have long attracted both native and non-native artists in search of exotic subject matter. However, most Southern landscapes move beyond the topographical and explore an almost metaphysical approach to place and meaning. Drawing from the Romantic tradition, Southern landscape painters often approach their subject with reverence and awe, using a variety of techniques and approaches to color to evoke this same metaphysical sense in the viewer. From the 19th century to the present, artists have continually reinvigorated the approaches defined by

Impressionism, Tonalism, Symbolism and Expressionism to explore the symbolic both as an expressive power of landscape painting and an exploration of place.

Uptown Street, painted in 1890 by Lulu King Saxon, is remarkable for its large scale and for its use of French landscape precedents. Here, the semi-rural, suburban region of Magazine Street in 19th-century New Orleans is reminiscent of the many similar roads that enter the rural villages, popularized by the French Impressionists in the 1870s and 1880s. Rendered in an atmospheric mood, reminiscent of French landscape painting descended from Corot, the Barbizon School and Impressionism, *Uptown Street* exemplifies the lasting influence of Europe on the art of the South. The continued importance of the Impressionist techniques of broken brushstrokes and heightened color extends well into the 20th century, evident in the works of Clara Caffrey Pancoast, Harold De Young and Louis Graner, traces of which may still be seen in contemporary Southern art. In contrast to European influences, the low-country South Carolina landscapes of Alice Ravenel Huger Smith find their inspiration in the delicate colors of the parallel landscape tradition of the Japanese print. Manipulating wet board colors with a dry brush, Smith's delicate Japonisme approaches the poetic boundaries of landscape painting.

Whether in search of the sublime vistas of the mountains, the exoticism of the bayous and marshes, or the majesty of the sea, the need to render place and time in an emotionally engaging way has persisted through the many stylistic changes that redefined the art of the South.

1
Lulu King Saxon
Uptown Street, 1890
Oil on canvas
228.6 × 172.7 cm
Gift of the Roger Houston Ogden Collection

2

Alexander John Drysdale

Sunlit Morning, June Roses, City Park, 1920

Oil on canvas

53.3 × 78.7 cm

Gift of the Roger Houston Ogden Collection

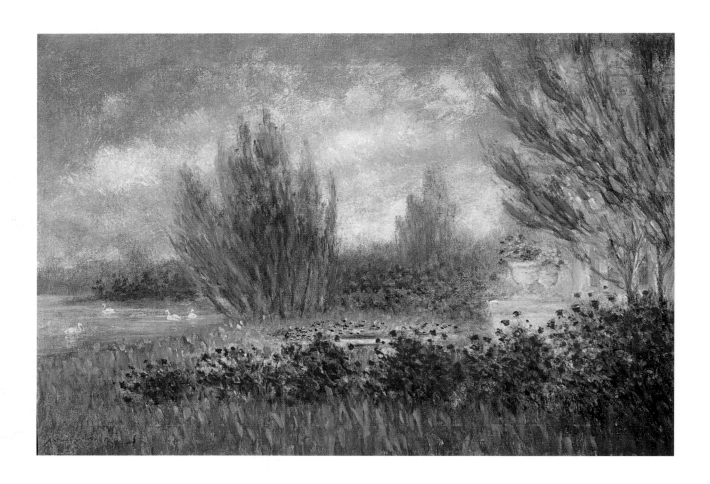

3
Robert Julian Onderdonk
Bluebonnet Scene with Girl, 1920
Oil on canvas
50.8 × 76.2 cm
Gift of the Roger Houston Ogden Collection

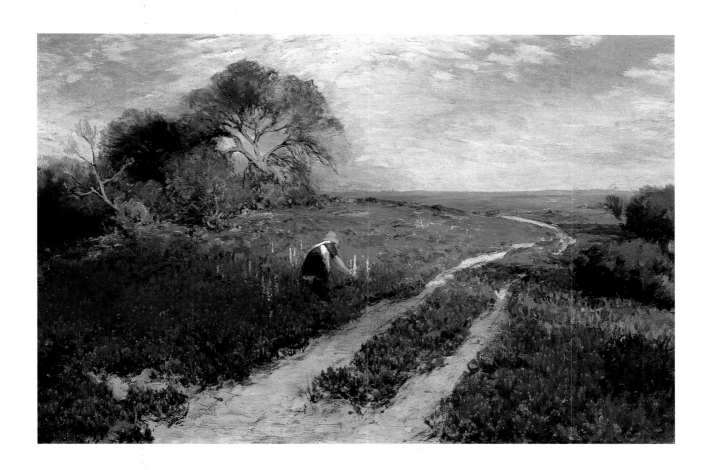

4

Ellsworth Woodward

First Light in the Pines, 1913

Oil on canvas

60.9 × 45.7 cm

Gift of the Roger Houston Ogden Collection

© 1913 Eleanor Woodward Westfeldt

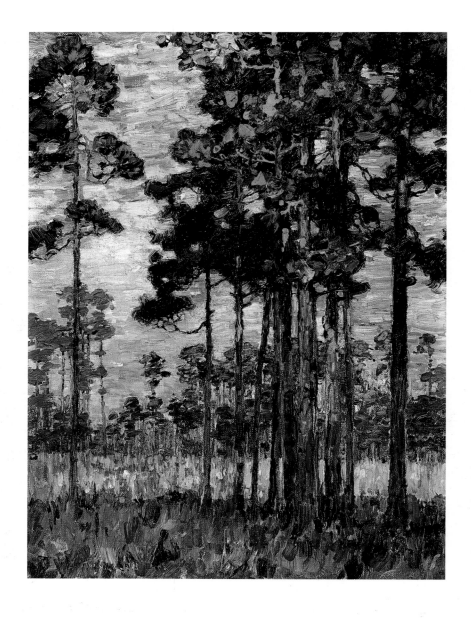

5
Adolph Robert Shulz
Morning Mist, Sarasota, FL, 1930
Oil on canvas
76.2 × 91.4 cm
Gift of the Roger Houston Ogden Collection

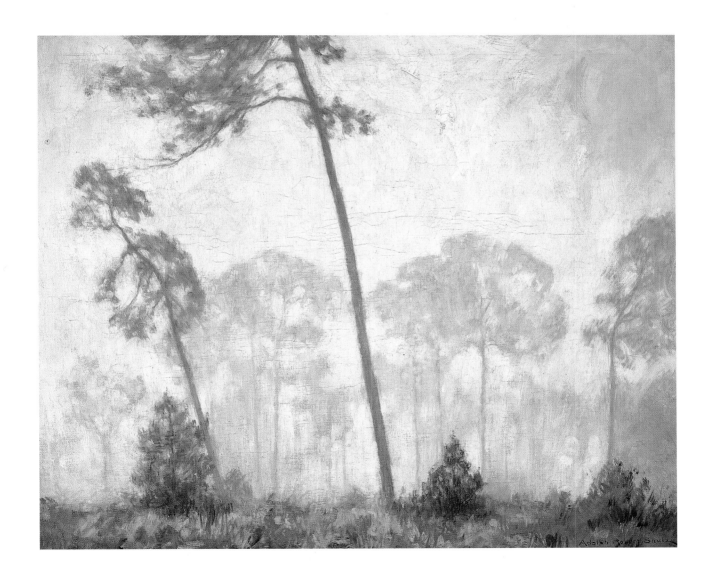

6
Louis Graner
Misty Marsh Along Lake Ponchartrain, 1920
Oil on canvas
101.6 × 121.9 cm
Gift of the Roger Houston Ogden Collection

7
Edward Eisenlohr
November, 1916
Oil on canvas
40.6 × 60.9 cm
Gift of the Roger Houston Ogden Collection

8
Clara Caffery Pancoast
Midday Landscape, Texas Hill Country, 1929
Oil on board
38.1 × 48.2 cm
Gift of the Roger Houston Ogden Collection

9
Harry Anthony de Young
Peaceful Valley, 1930
Oil on canvas
53.3 × 46.9 cm
Gift of the Roger Houston Ogden Collection

10
Alice Ravenel Huger Smith
Early Spring, 1920
Watercolor on paper
78.7 × 55.8 cm
Gift of the Roger Houston Ogden Collection

11
William Posey Silva
The Cathedral Window, 1930
Oil on board
50.8 × 60.9 cm
Gift of the Roger Houston Ogden Collection

2 | Charleston, South Carolina and New Orleans, Louisiana

The port cities of Charleston, South Carolina and New Orleans, Louisiana have long been important cultural centers of the South. Charleston has been a thriving mercantile and artistic center since the antebellum period and, in addition to supporting a community of artists, attracted many important itinerant portrait painters. Housing both a theater and gallery, the Dockstreet Theater is the oldest theater in North America, providing an important focal point for the city's cultural life. Charleston fell into an economic and cultural decline after the Civil War, but regained its role as an important cultural center during the Charleston Renaissance of the 1920s and 1930s. Artists such as Alfred Hutty, Elizabeth O'Neill Verner, Anna Heyward Taylor and Alice Ravenel Huger Smith concentrated on Charleston scenes and low-country landscapes in parallel with the development of American Scene painting and Regionalism. Verner's view of St. Michael's Episcopal Church in *Summertime in Charleston* captures one of the landmarks that still dominates Charleston's skyline. This renewed artistic inheritance continues today, with many artists living and working in the city; it is also the site for the Spoleto Festival U.S.A.

New Orleans' French Quarter has long been a haven for artists, writers and musicians in search of a free approach to life and a larger sense of cultural community. As the epicenter of Bohemian New Orleans, the Quarter was known as the "Paris of the South" and the accomplishments of its many distinguished residents have made lasting contributions to American art, music and literature. Swedish native Knute Heldner visited New Orleans for the first time in 1926 and chose to stay. He soon became one of the well-known artists working in the Quarter and found many of his subjects there. Unlike Verner's painting of St. Michael's, Heldner's view does not focus on a prominent landmark, but captures the unique architectural fabric that attracted so many artists to the city.

Although very different in history and character, Charleston, South Carolina, and New Orleans, Louisiana remain two of the most important cultural centers of the South. Their picturesque architecture and greater sense of cultural community are qualities still unique to the region.

12
William Woodward
French Quarter Street Scene, 1909
Raffaelli solid oil colors on academy board
35.6 × 25.4 cm
Gift of the Roger Houston Collection
© 1913 Eleanor Woodward Westfeldt

13

Sven August Knute Heldner

French Quarter Roof Tops From His Studio, 1923

Oil on canvas

60.9 × 55.8 cm

Gift of the Roger Houston Ogden Collection

14

Elizabeth O'Neill Verner

Summertime in Charleston, 1940

Pastel on silk

63.5 × 50.8 cm

Gift of the Roger Houston Ogden Collection

© 1940 Estate of Elizabeth O'Neill Verner/Licensed by VAGA, New York, NY

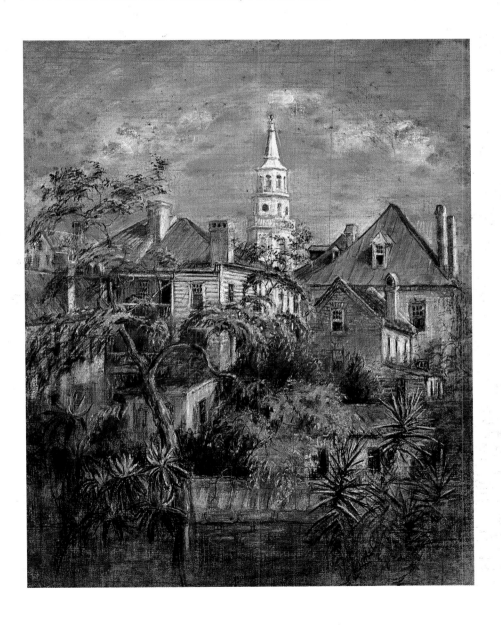

3 | Southern Art in the 1930s: The American Scene and Regionalism

The subject that would come to be known as American Scene painting in the 1930s, flourished in the South before and after its prominence as a national trend from the mid-1920s through the late 1940s. Anticipating the development of American Scene painting by more than a decade, Harold Betts' *On the Levee at Natchez* captures the slow rhythm of daily life on the Mississippi River. Unlike the urban subjects and academic techniques of the Ash Can School, Betts' genre painting defines life on the Mississippi with a snapshot-like clarity and relaxed mood suitable for his pastoral subject. The American Scene painters and the American Regionalist movement celebrated the rural as a reaction against the encroachment of the modern world. Many early painters of the Southern Scene were simply responding to everyday life from their immediate world. In the 1930s the continued revolution of an indigenous approach to regionalist subjects may be seen in the directness and dignity of Marie Hull's *Tenant Farmer* and the stylized, dance-like compositions of Christopher Clark's *The Crap Shooters* and John Kelly Fitzpatrick's *Mules to Market*.

The Federal Art Project of Franklin Delano Roosevelt's New Deal was an important force for the cultural development of artists and civic art across the country, and was particularly influential in the South. Before its termination during the height of World War II, the Federal Art Project had sustained over 3,600 artists across the country, including many in the Southern states. In addition to relief for artists, the FAP also supported public art in new Federal courthouses, post offices and other federal buildings across the region. This government patronage set an important precedent for public art that would be renewed by national and state agencies, and many corporations in the 1970s.

If Betts' *On the Levee at Natchez* demonstrates the existence of an early school of Southern Scene painters that anticipates the development of American Scene painting as a national trend, *The Parade* by New Orleans painter John McCrady is an argument for the lingering importance of Regionalist approaches in the South. McCrady was schooled in Oxford, Mississippi, the Pennsylvania Academy of Fine Arts, and the Art Students League of New York, where he briefly studied with Regionalist painter Thomas Hart Benton. McCrady worked on the Federal Art Project and became an important example of the development of Regionalist painting in the South. McCrady's art school became an important cultural center in the New Orleans French Quarter's Bohemian art scene, and provided training for many New Orleans painters that came to prominence in the 1950s and 1960s. *The Parade*, painted in 1950, utilized the cutaway composition exploited by many artists of the period to explore the vitality of the interior world of the artist's studio and the street life of New Orleans, both compelling reasons to continue working in the narrative style of Regionalist art into the 1950s.

Richard Wilt's *Farewell* points to the end of an era. Painted in the 1930s narrative style, Wilt's painting contrasts the old agrarian South—symbolized by the rundown house, dilapidated car and out-house—with the bombers that symbolized the progress and change precipitated by World War II. Here, the modernity and industrialization that prompted the re-evaluation of American life by the Regionalists appears to be a welcome agent of change for the oppressed in the Old South.

15

Harold Harrington Betts
On the Levee at Natchez, 1904
Oil on canvas
111.7 × 109.2 cm
Gift of the Roger Houston Ogden Collection

16

Helen M. Turner
Portrait of a Lady, 1938
Oil on canvas
76.2 × 63.5 cm
Gift of the Roger Houston Ogden Collection

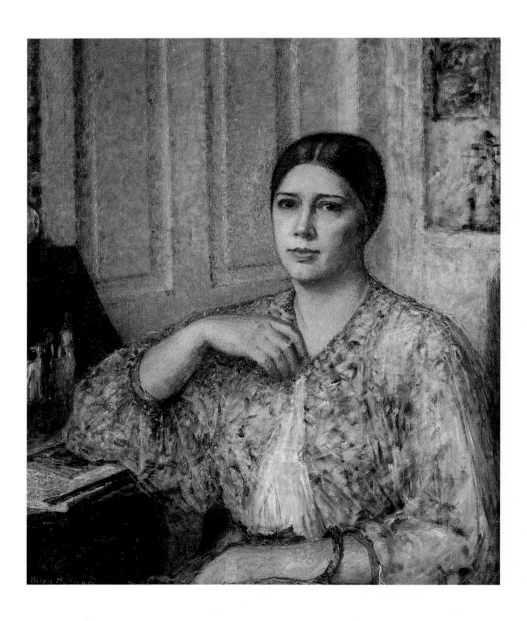

17
Marie Atchinson Hull
Tenant Farmer, 1935
Oil on canvas
91.4 × 76.2 cm
Gift of the Roger Houston Ogden Collection

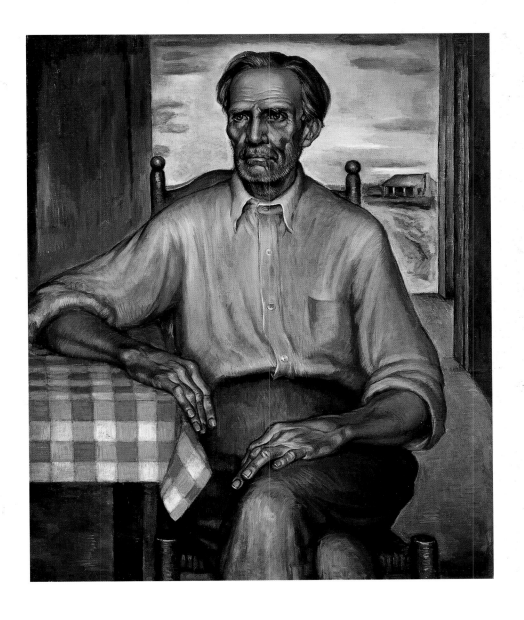

18
Christopher Clark
The Crap Shooters, 1936
Oil on canvas
76.2 × 91.4 cm
Gift of the Roger Houston Ogden Collection

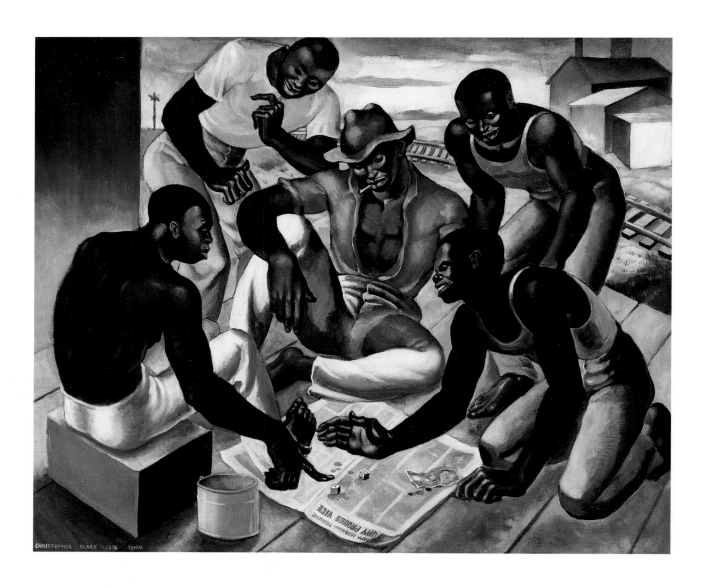

19
Clarence Millet
Bayou Bridge, 1925
Oil on canvas
78.7 × 104.4 cm
Gift of the Roger Houston Ogden Collection

20
John Kelly Fitzpatrick
Mules to Market, 1937
Oil on canvas
76.2 × 91.4 cm
Gift of the Roger Houston Ogden Collection

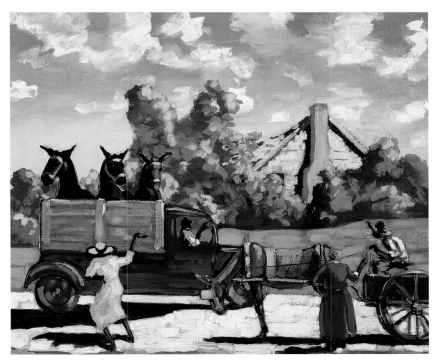

21
John McCrady
The Parade, 1950
Oil on canvas
50.8 × 110.4 cm
Gift of the Roger Houston Ogden Collection
© 1950 Blake Woods

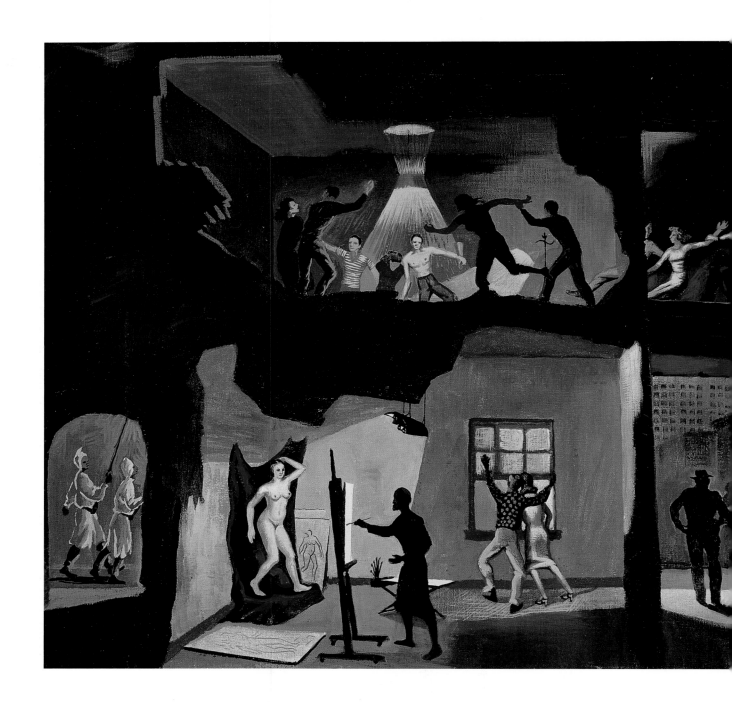

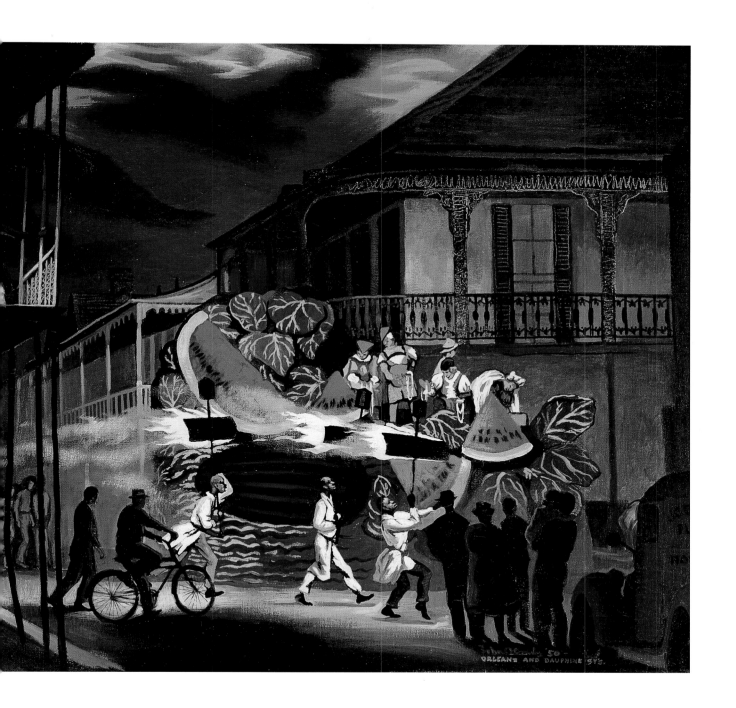

22
Crawford Gillis
Women Praying, Holiness Church, 1940
Oil on canvas
67.3 × 84.4 cm
Gift of the Roger Houston Ogden Collection

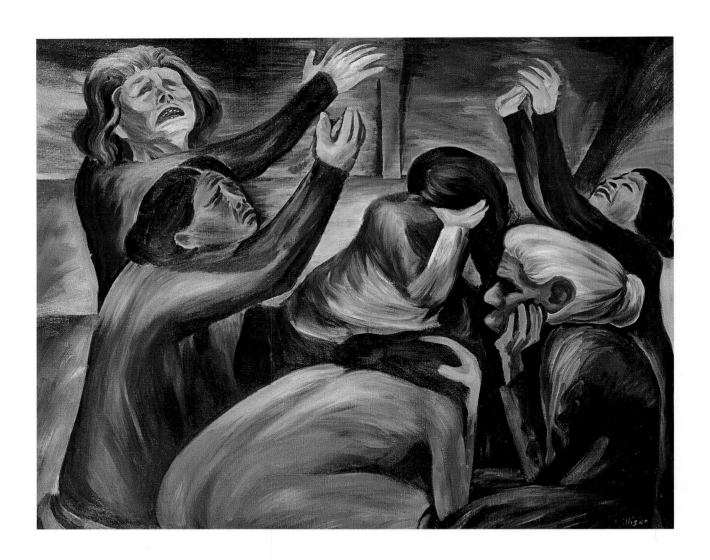

23
Richard Wilt
Farewell, 1943
Oil on canvas
71.1 × 71.1 cm
Gift of the Roger Houston Ogden Collection
© 1943 Ellen Wilt

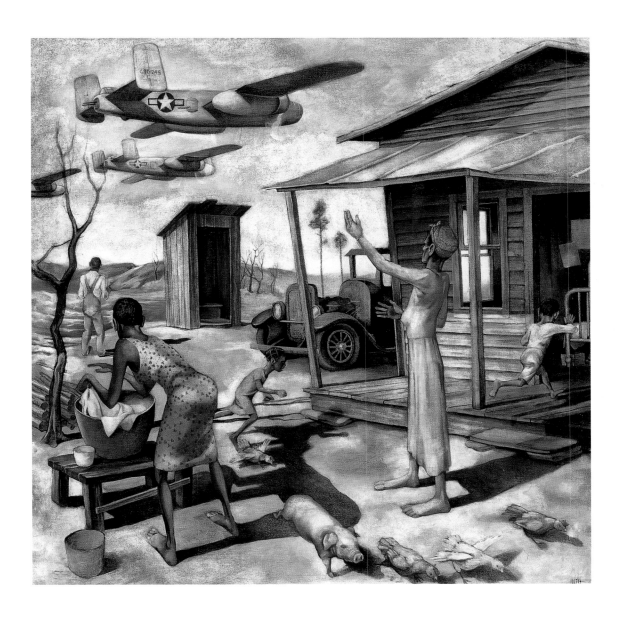

24
Walter Inglis Anderson
Pelicans, 1945
Watercolor and pencil on typing paper
63.5 × 48.2 cm

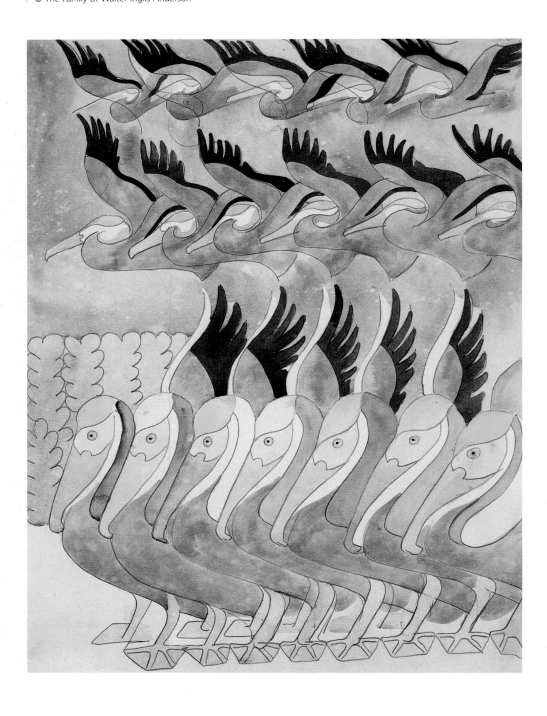

4 | **Modernism and Abstraction**

Modernism is a movement and attitude usually associated with the urban life of Northern industrialized cities rather than the South. In a region where the "shock of the new" often remains just that, modernist ideas and techniques were slow to penetrate the region, especially the popular imagination. Despite a less-than-receptive environment, many Southerners were compelled to experiment with the abstract formal language of modern art. Working in an area beyond the reach of direct modernist influences, and with access to few examples of modern art, Southern modernists were forced to forge their own individual paths to abstraction. Some sought training outside of the region, and several artists, such as Fritz Bultman and Ida Kohlmeyer, found their way to Hans Hofmann's circle in Provincetown, Massachusetts. Some, for many reasons, lived and worked in the South throughout their lives, making periodic trips to New York to experience modern art first-hand. Many eventually felt the need to relocate to New York City.

Will Henry Stevens, one of the most profound and least-known American modernists, came to Newcomb College to teach at the invitation of the Woodward brothers, Ellsworth and William. Inspired by the American Transcendentalists, nature mysticism and the theories of Vassily Kandinsky, Stevens simultaneously pursued a mystical realism that attempted to reach beyond the realm of appearances as well as a highly personal approach to non-objective art. He taught at Newcomb College in New Orleans, summered in the mountains of North Carolina and made annual pilgrimages to New York City, where he maintained contact with Hilla Rebay at the Museum of Non-Objective Art (now the Guggenheim Museum). His untimely death in 1948 came just as American modern art was gaining larger recognition.

Mississippi native Dusti Bongé studied and lived in Chicago and New York before returning to Biloxi in the early 1930s. Her husband, Archie Bongé, had been trained at the Pennsylvania Academy and encouraged Dusti to accompany him on expeditions to sketch and paint local architectural scenes. After Archie's untimely death in 1936, Dusti gradually developed her own instinctual style of Abstract Expressionist painting that earned her representation in the influential Betty Parsons Gallery in New York.

Gulf Coast artist Walter Anderson studied at the Pennsylvania Academy, after which he spent two years traveling in France. There he absorbed both the lessons of the new French painting and the spirituality of French Gothic architecture. After returning to the States, he worked at Shearwater Pottery in Ocean Springs during the mid-1930s before being institutionalized with a mental breakdown. Upon his release, Anderson returned to the family compound at Shearwater where he often worked out-of-doors and frequently paddled his handmade canoe to the barrier islands along the Gulf Coast. Of the thousands of works found after his death, his most celebrated are repeating plant and animal forms composed with the modern concept of dynamic symmetry. Anderson's sensitive and obsessive transcription of nature underscores the overwhelming importance of place to many Southern artists.

Fritz Bultman followed a path that took him from the Deep South to studies in Munich, the new Chicago Bauhaus, Hans Hoffman's circle and finally to the inner circle of Abstract Expressionist painters in New York City. His large bold forms and emotionally charged sense of color are rooted in the rich textures and experiences of an artistic childhood spent in New Orleans.

The optimism and progressive spirit that swept the country in the 1950s and 1960s fostered an environment more receptive to modern technical innovations and institutional architecture. The fractured, fast-paced experience of contemporary urbanity, however, remained alien to much of the South. Modern painting and sculpture found its most receptive home in the developing college and university art departments, and the spin-off art galleries in the region. Funded by the growth of federal education funding in the 1960s, the expanding importance of art in American society was an integral part of the idealism of The Great Society, an expansion of the progressive spirit embedded in the spirit of modernity. Within this changing climate, many Southern artists were inspired to pursue the new modernist art while choosing to remain in the South. Both making Abstract Expressionist-inflected artworks, Bess Dawson (Summit, Mississippi) and Vincencia Blount (Atlanta, Georgia) are prime examples of artists that work in the South while pursuing the aesthetic of the New York School.

25

Will Henry Stevens
Untitled (Mountain Landscape with Lake), c.1930
Pastel on paper
40.6 × 45.7 cm
Will Henry Stevens Collection
© 1930 Joscelyn W. Hill

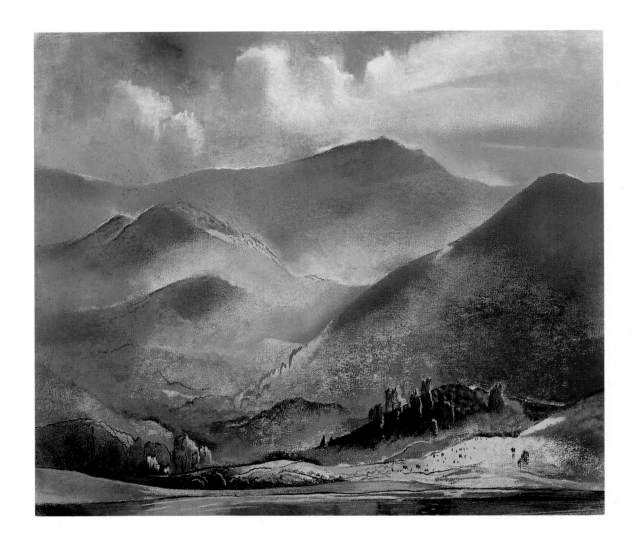

26

Will Henry Stevens
Untitled (Blue Background with Multicolored Circles), c.1930
Oil on board
55.8 × 66 cm
Will Henry Stevens Collection
© 1930 Joscelyn W. Hill

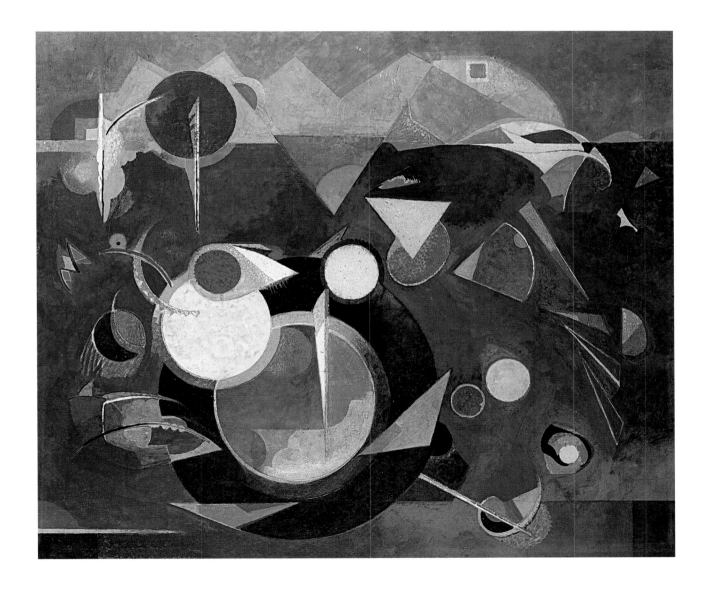

27
Dusti Bongé
Untitled (Biloxi Cottage), 1937
Oil on canvas
41.9 × 52 cm
Gift of The Dusti Bongé Foundation
© 1937 The Dusti Bongé Foundation

28
Dusti Bongé
Circles Penetrated, 1942
Oil on canvas
119.3 × 83.8 cm
Gift of the Dusti Bongé Foundation
© 1942 The Dusti Bongé Foundation

29
Bess Dawson
Red Glow, 1959
Oil on masonite
91.4 × 81.2 cm
Gift of the Roger Houston Ogden Collection

30
Paul Ninas
Dancing Figures, 1950
Oil on canvas
91.4 × 114.3 cm
Gift of the Roger Houston Ogden Collection
© 1950 Paul Ninas

31
Vincencia Blount
Untitled, 1977
Oil on paper
71.1 × 87.6 cm
Promised Gift of the Artist, Vincencia Blount
© 1977 Vincencia Blount

32
Fritz Bultman
Ante Luce, 1983
Collage of painted paper
119.3 × 175.2 cm
Gift of the Roger Houston Ogden Collection
© 1983 Jeanne Bultman

33

Benny Andrews
Death of the Crow, 1965
Oil on canvas
88.9 × 60.9 cm
Promised Gift of the Benny Andrews Foundation
© 1965 Benny Andrews

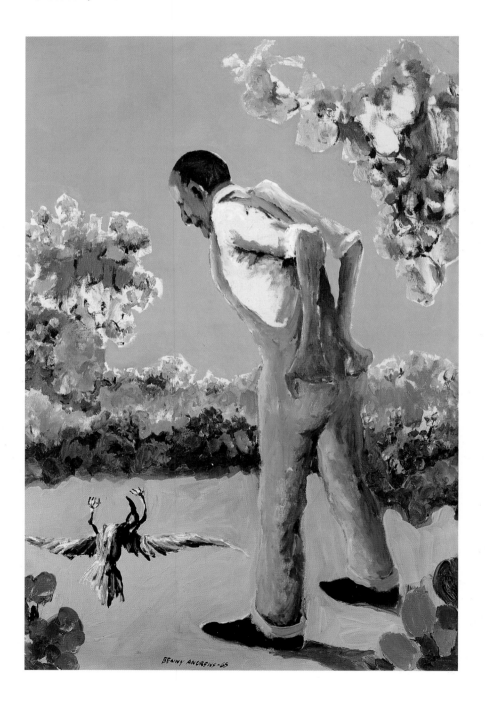

5 | Narrative

In a region known for its strong oral tradition and distinguished music and literature, the importance of narrative painting cannot be overestimated. Realistic scenes of uncommon communicative power have long been repositories of history and memory in American art, but this genre is particularly important and long-lasting in the South. Narrative painting found a receptive climate in the United States during the first half of the century with the rise of American Scene painting and Regionalism, which created a new American art of national identity. From the 1950s through the 1970s, the increasing influence of abstract art in publications, galleries, and college and university art departments posed a significant challenge to the primacy of realist narrative. Many modern artists saw the changing cultural climate in progressive and exclusionary terms, arguing that realism represented the art of the past while abstraction led the path to the future. In this view, as abstract art grew, realistic art would necessarily diminish and, as some argued, would eventually disappear. In the South, many artists did see realism and abstraction in exclusionary terms. Those who pursued abstraction often never completely abandoned a perceptual basis as the starting point for their work. Not only did Southern narrative painting survive the challenge of modern abstraction but it reasserted its primacy in an unbroken line of evolution, when realist painting once again returned to prominence on the national scene.

Benny Andrews' *Death of the Crow* is an important example of Southern narrative painting that draws from both personal and collective history to create a work of narrative power and symbolism. Born of a multicultural family (African-American, Native-American and European-American descent) in rural Georgia, Benny Andrews left the South and eventually settled in New York City. There he continued to reflect back on his experiences as a Southerner as he rose to national prominence. *Death of the Crow* looks back at one of the major political shifts of Southern history—the death of the "Jim Crow" laws—which represents the passing of a political era and a broader realization of the democratic ideals in American society. Deceptively simple, *Death of the Crow* attests to the renewed importance of narrative painting on both regional and national levels.

Going Home, by Willie Birch, recounts the story of the children of the great migration as they return to the South. Using the humble medium of papier mâché, a purposeful Southern Arte Povera, Birch constructs a narrative that is psychologically complex. *Going Home*, while directly symbolic and replete with subtle iconography, also functions as an open text, engaging the viewer to become a participant in constructing the narrative possibilities of the work. Born in New Orleans, Birch's work gained national recognition during his years in New York City. Today he is investigating the possibilities of community-based art, inspired by the history and people of the historic Tremé neighborhood where he maintains a studio.

William Christenberry's work explores time and place embedded in history and memory. Christenberry was born in Hale County, Alabama, the location of James Agee's and Walker Evans' ground-breaking book documenting the plight of sharecroppers in the South—*Let Us Now Praise Famous Men*. After training as an Abstract Expressionist painter, Christenberry's discovery of this book challenged him to rethink the importance of place in his own work; in this case the representation of his family's world by others. Utilizing painting, drawing, sculpture, photography and installation art, Christenberry distills the spirit of place through works that are often literal representations, yet also strangely evoke the spirit of time and accumulated history.

Contemporary Southern narrative painting reflects the renewed interest in representational art that increasingly influenced American art after the 1970s. However, it is important to recognize that, in the South, traditional narrative art was never eclipsed by abstract painting. Particularly important to this realist revival is the development of a climate of pluralism that simultaneously opened up new aesthetic directions and prompted a re-evaluation of the past. The new narrative art, as seen in the work of Fredrick Trenchard and Justin Forbes, was an amalgam of styles and attitudes, at once historically aware and distinctively ironic. The contemporary revival of realist, narrative art did not eclipse abstraction and experimental art, but developed as an equally important parallel movement. The resulting expansion of artistic possibilities not only redefines our assumptions about the history of art but also continues to define the ever-changing practices of contemporary art.

34
Noel Rockmore
Kid Sheik, Preservation Hall, 1963
Oil on canvas
127 × 96.5 cm
Gift of the Roger Houston Ogden Collection
© 1963 Emilie Heller-Rhys

35
Wolf Kahn
My Louisiana Studio, 1952
Pastel on paper
26.6 × 30.4 cm
Gift of Jerald and Mary Melberg
© 1952 Wolf Kahn

36 (left)
Fred Trenchard
Massacre of the Innocence, 1971
Oil on canvas
180.3 × 182.8 cm
Gift of the Michael Brown and Linda Green Collection
© 1971 Fred Trenchard

37
Robert Warrens
Carpet Tacks, 1980–1985
Acrylic on canvas
228.6 × 182.9 cm
Gift of the Roger Houston Ogden Collection
© 1985 Robert Warrens

38
Justin Forbes
Neo-American Gothic, 1996
Oil on canvas
142.8 × 132 cm
Gift of the Michael Brown and Linda Green Collection
© 1996 Justin Forbes

39

Douglas Bourgeois

Elvis and Dice Curtains, 1981

Oil on canvas

76.2 × 76.2 cm

Gift of the Roger Houston Ogden Collection

© 1981 Douglas Bourgeois

40

Clyde Broadway

Trinity—Elvis and Jesus and Robert E. Lee, 1994

Acrylic on canvas

93.9 × 124.4 cm

Gift of the Roger Houston Ogden Collection

© 1994 Clyde Broadway

41
Willie Birch
Going Home, 1992
Papier mâché and mixed media
139.7 × 99 × 94 cm
Gift of the Roger Houston Ogden Collection
© 1992 Willie Birch

42
Alexander Stolin
Hascal Agee, 2001
Graphite on panel
30.4 × 30.4 cm
Gift of Dale and Janet Stram
© 2001 Alexander Stolin

43

William Dunlap

Landscape and Variable: The Bounty and Burden of History, 1988

Mixed media and polymer paint on canvas

167.6 × 238.7 cm

Gift of the Roger Houston Ogden Collection

© 1988 William Dunlap

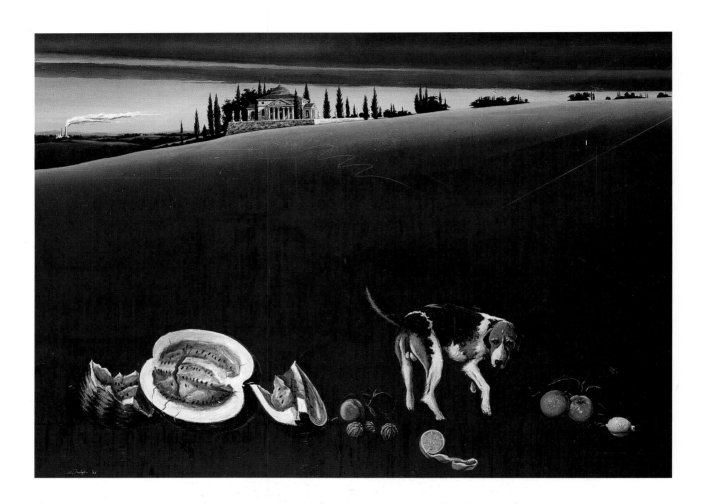

44

William Christenberry

Abandoned House in Field (View III), near Montgomery, Alabama, 1971

Ektacolor Professional Brownie print

8.2 × 12.7 cm

Gift of the Roger Houston Ogden Collection

© 1971 William Christenberry

45

William Christenberry

Ghost Form, 1994

Mixed-media sculpture and red soil

42.5 × 86.3 × 50.8 cm

Gift of the Roger Houston Ogden Collection

© 1994 William Christenberry

46
William Moreland
VIII, 2000
Acrylic and pencil on board
63.5 × 48.3 cm
The Mary Lee Eggart Collection
© 2000 William Moreland

47
Elemore Morgan, Jr.
View from the Prairie, 1988
Acrylic on masonite
238.8 × 358.1 cm
Gift of the Roger Houston Ogden Collection
© 1988 Elemore Morgan, Jr.

48
Arless Day
Family Dreams, 2001
Mixed media
35.5 × 81.2 cm
Gift of the Artist, Arless Day
© 2001 Arless Day

49
Edward Rice
Gable Window, 1999–2000
Oil on canvas
106.6 × 76.2 cm
Gift of Edward Rice in honor of Freeman and Cora Schoolcraft
© 2000 Edward Rice

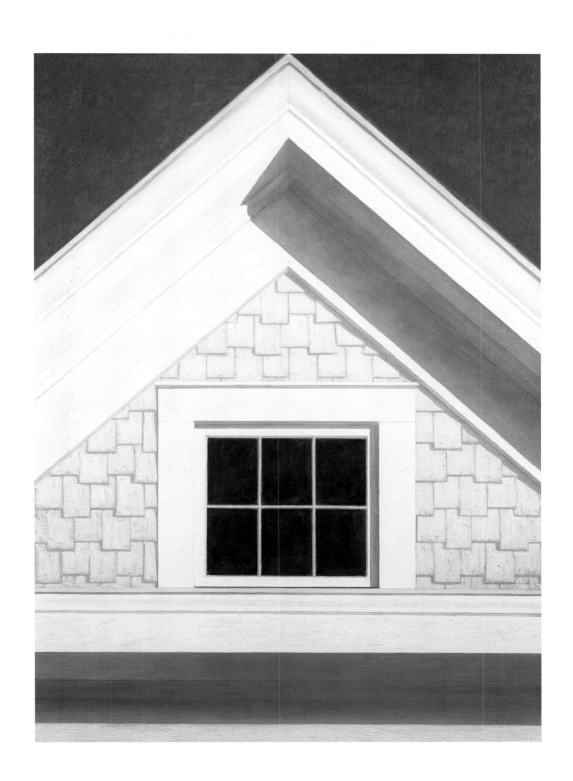

50
Ida Kohlmeyer
Fenestrated #6, 1993
Painted aluminum
241.3 × 58.4 × 106.6 cm
Gift of Ida and Hugh Kohlmeyer Foundation,
the Robert A. Katz Memorial Foundation,
Roger Houston Ogden and Arthur Roger
© 1993 Ida and Hugh Kohlmeyer Foundation

6 Contemporary Abstraction and Mixed-Media Art

From the enactment of the GI Bill in 1946 through the expansion of college and university art departments in the 1950s and 1960s, Southerners increasingly gained access to diverse art training, both within and outside the region. The expansion of schools within the region brought many new teachers and, with them, current ideas and recent avant-garde trends in modern art. As these departments grew, they offered the possibility of jobs that helped support the growing number of artists working in the South. New and expanded educational options, increased travel and the growth of arts publications all contributed to a climate of change and more openness in the South, which reduced the conceptual gap between Southern artists and mainstream cultural developments.

Over the last two decades the boundaries between Southern art and national trends have become less distinct and increasingly complex. The phenomena of Southern chic in food, music and sports in combination with the Sun Belt migration, have created a broad national awareness of Southern regional identity, both genuine and clichéd. Simultaneously, the instantaneous awareness of cultural trends and the increased national prevalence of Southern artists (both trained and self-taught) has forced artists working in the region to re-examine the over-used and changing issues of regional identity. Whether realistic, abstract or experimental, little Southern art produced today is unaware of the many issues of regional identity and the contradictory questions they raise in the 21st century.

In the 1950s and 1960s, many artists working in the South were compelled to work in the dominant style of abstraction, popularized by the New York School. By the mid-1950s Abstract Expressionism had become the new national style sanctioned by the most influential critic of the period, Clement Greenberg, as "American type painting." By the 1960s the new American painting had become not only the new internationally dominant trend but also a new academic model that influenced two generations of artists.

The painting of Ida Kohlmeyer is an example of a Southern artist who remained in the South, but responded very directly to the new American abstract painting. Kohlmeyer began painting in her 30s, rapidly assimilating the styles of Realism, Regionalism and Surrealism in a short period of time. Her contact with Mark Rothko at Tulane University in the 1950s and her further studies with Hans Hoffman in Provincetown, Massachusetts, solidified her commitment to abstraction and opened the way for her to develop a personal approach to non-objective painting. By the late 1950s, she developed her signature style of intuitive mark making, which eventually incorporated intuitive pictographic symbols floating in a field of sensuous color.

Kendall Shaw, a graduate student of Ida Kohlmeyer at Tulane University, assimilated the influences of Mark Rothko, Ralston Crawford and Stuart Davis. In New York City Shaw gained national and international recognition in the 1970s and 1980s for his leadership in the Pattern and Decoration movement, which redefined abstract American painting by questioning the formalist limitations of Abstract Expressionism.

Clyde Connell's work is an investigation of materials grounded in place, in this case northwestern Louisiana. Connell's paintings and sculpture are based on an intuitive investigation into forms and materials that are suggestive of the past, but speak to the present. Her work, though highly personal, shares a concern for process and experimentation with materials, common to many post-minimal sculptors of the period.

Sculptor Keith Sonnier utilizes contemporary materials and processes associated with modern technology to poetic ends. Like many Southern artists, his work evokes memory and place.

51
Kendall Shaw
Emma Lottie's Scandalous Divorce, 1979
Mixed media
251.4 × 139.7 cm
Gift of the Artist, Kendall Shaw
© 1979 Kendall Shaw

52

Ida Kohlmeyer

Mythic Series #31, 1985

Mixed media on canvas

172.7 × 196.8 cm

Gift of the Roger Houston Ogden Collection

© 1985 Ida and Hugh Kohlmeyer Foundation

53
Clyde Connell
Pondering Place, 1981
Mixed-media sculpture
203.2 × 63.5 × 63.5 cm
Gift of the Roger Houston Ogden Collection
© 1981 Courtesy: Arthur Roger Gallery

54
Jesús Bautista Moroles
Black Interlocking Diptych, 1984
Black granite
101.6 × 87.6 × 8.9 cm
Gift of the Michael Brown and Linda Green Collection
© 1984 Jesús Bautista Moroles

55
Sam Gilliam
Drape Work, 1970
Acrylic on canvas
274.3 × 274.3 × 106.6 cm
Gift of the Roger Houston Ogden Collection
© 1970 Sam Gilliam

56
Nene Humphrey
A Wild Patience #2, 1996–1997
Blankets, celuclay, wood and granite
101.6 × 45.7 × 231.4 cm
Promised Gift of the Benny Andrews Foundation
© 1997 Nene Humphrey

57
Lynda Benglis
Minerva, 1986
Bronze, nickel and chrome
139.7 × 96.5 × 20.3 cm
Gift of the Roger Houston Ogden Collection
© 1986 Lynda Benglis/Licensed by VAGA, New York, NY

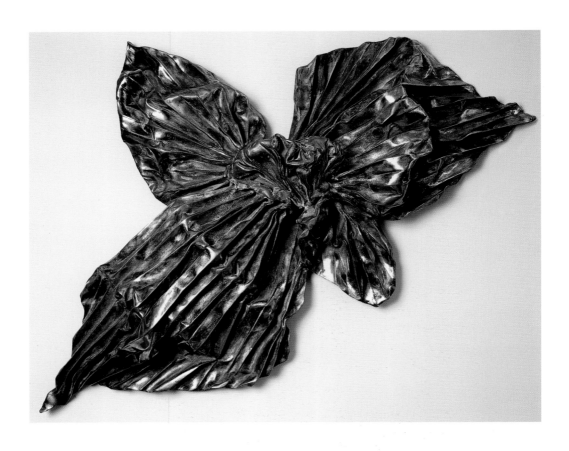

58

Keith Sonnier
Split Dyad-C, 1990
Neon, glass, mirror and aluminum
182.8 × 91.4 × 25.4 cm
Gift of the Roger Houston Ogden Collection

Photography in the South

Southern photography is perhaps more influenced by national trends than any other media. By the beginning of the 20th century, photography had established a place for itself in the public consciousness, based on two opposing approaches: the factual accuracy of the documentary and the flights of soft-focus pictoralist art. The evolving approach to art photography found its inspiration in the pictoralist tradition of highly aestheticized soft-focus landscapes and female nudes, but by the second decade of the century this fuzzy romanticism gave way to the photo-as-document factualism inherent in the medium. The "documentary style" found its zenith with the monumental Farm Services Administration photography program, which documented rural America's hardships during the Great Depression. Ben Shahn, Walker Evans and Marion Post Wolcott all made important photographs of the South, and their direct, documentary style is still influential throughout the region. During the 1930s and early 1940s, the South became fertile subject matter for these and other non-Southern photographers, a trend that began in the Depression and accelerated through the era of postwar segregation, the Civil Rights movement and the making of the New South.

Few photographers captured the slowly vanishing folk traditions and indicators of modern progress of the transforming South as well as the Louisianans Theodore Fonville Winans and Elemore Morgan, Sr. Winans was attracted by the distinctive region around the bayous of Southwestern Louisiana and the Acadians (or Cajuns) that populate the region. His photographs of the poor and powerful of Louisiana reveal an artist who understands his subjects from within the culture. Working from the late 1940s to the early 1960s, Elemore Morgan, Sr., captured modern progress impinging on the rural folk life of the old South. As a commercial photographer Morgan amassed thousands of photographs, whose subject matter ranged from the oil and timber industries to the rise of modern architecture in the region and the airline industry. During this same period, he provided photographs for several books that document vanishing patterns of life in the face of industrial development and modern ideas of progress; this constituted his other body of professional work.

William Eggleston came to the attention of the wider art world in 1976 with the first color photography exhibition to be shown at the Museum of Modern Art in New York City, and has defined the emergence of an influential aesthetic of Southern photography. Eggleston's work was met with hostility by most, lead by Hilton Kramer, writing in the *New York Times*. The reviews concentrated on the perceived banality of the mostly Southern subject matter of this Mississippi-born, Memphis-based artist. Eggleston's exhibition was controversial on one level, being the first exhibition of color photography at the institution. However, re-reading the critical articles today, we realize that Eggleston's singular vision, strongly rooted in a place that was decidedly unfashionable at the time, was completely misunderstood by the northeastern art establishment, obsessed with the formal values of late Modernism. Eggleston's sophisticated use of fragments of everyday experience has since been celebrated, and represents one of the most influential trends in photography over the last decade. Today photography has become the common language of world culture, bringing with it many new possibilities, but also a glut of images that continually challenge the boundaries of art, documentation and commercial photography. In such a climate Southern photographers often seem more Southern as they further investigate issues of place and identity, and less Southern as their approaches exert a growing influence beyond the region.

59
Ogle Winston Link
Hot Shot Eastbound Leager, West Virginia, 1956
Silver gelatin photograph
40.6 × 50.8 cm
Gift of the Roger Houston Ogden Collection
© 1956 O. Winston Link Trust

60
Anonymous
St. Charles Hotel, 1910
Black and white photograph
40.6 × 50.8 cm
Gift of the Roger Houston Ogden Collection

61

Unknown photographer

Crescent City Jockey Club, 1906

Black and white photograph

40.6 × 50.8 cm

Gift of the Roger Houston Ogden Collection

Library of Congress, Prints and Photographs Division,

Detroit Publishing Company Collection

62
Theodore Fonville Winans
Native Shrimpman, Grand Isle, LA, 1934
Black and white photograph
50.8 × 40.6 cm
Gift of the Roger Houston Ogden Collection
© 1934 Fonville Winans.com

63

Theodore Fonville Winans

Huey and President Smith, Baton Rouge, LA, 1934

Black and white photograph

50.8 × 40.6 cm

Gift of the Roger Houston Ogden Collection

© 1934 Fonville Winans.com

64
Walker Evans
Negro Houses, Atlanta, GA, 1936
Black and white photograph
20.3 × 25.4 cm
Gift of the Roger Houston Ogden Collection
Library of Congress, LC-USF34-4052

65
Ben Shahn
Church in Louisiana, 1935
Vintage silver gelatin photograph
20.3 × 25.4 cm
Gift of the Roger Houston Ogden Collection
Library of Congress, LC-USF34-4052

66
Ralston Crawford
Women in Front of Barber Shop, 1960
Gelatin silver print
35.5 × 43.1 cm
Gift of the Roger Houston Ogden Collection
© 1960 Ralston Crawford Estate

67

Clarence John Laughlin
Unending Stream, 1941
Black and white photograph
26.9 × 34.9 cm

Gift of the Roger Houston Ogden Collection

68

Elemore Madison Morgan, Sr.
Burning on the Pit (a Wildcat is Loose), 1953
Black and white photograph
61 × 50.8 cm
Gift of the Roger Houston Ogden Collection
© 1953 Elemore Morgan, Jr.

69
G. E. Arnold
Construction of Superdome, c.1971
Silver gelatin print on RC paper
21.5 × 31.1 cm

70
Lyle Bongé
Untitled, c.1962
Silver gelatin print
20.3 × 25.4 cm
Gift of the Dusti Bongé Foundation
© 1962 Lyle Bongé

71
Lyle Bongé
Mardi Gras—Clown in Window, 1964
Silver gelatin print
20.3 × 25.4 cm
Gift of Paul Bongé
© 1964 Lyle Bongé

72

Jack Spencer

Baptismal Candidates, Moon Lake, MS, 1995

Black and white photograph

35.5 × 35.5 cm

Gift of the Roger Houston Ogden Collection

© 1995 Jack Spencer

73

Maude Schuyler Clay

Two Spired Church, 1998

Sepia tones, silver gelatin print

50.8 × 60.9 cm

74

Thomas Rankin

Mt. Airy M. B. Church, Friars Point, 1990

Black and white photograph

35.5 × 45.7 cm

75

Jack Kotz

Bill's Chair, 1993

C-type color photographic print

55.8 × 66 cm

Gift of the Artist, Jack Kotz

© 1993 Jack Kotz

76
Birney Imes
Magic Star Disco, Falcon, MS, 1984
C-type color photographic print
50.8 × 60.9 cm
Gift of the Roger Houston Ogden Collection
© 1984 Birney Imes

77

David Rae Morris

Cafeteria, Stennis Space Center, Hancock County, 1999

C-type color photographic print

27.9 × 35.5 cm

Gift of the Artist, David Rae Morris

© 1999 David Rae Morris

78

William K. Greiner

Running Shoe in Driveway at Night, New Orleans, LA, 1993

C-type color photographic print

40.6 × 50.8 cm

Gift of the Artist, William K. Greiner

8 | Craft, Arts and Crafts, and Craft as Art

Southern craft forms have remained important signifiers for the ongoing dialogue between tradition and innovation in the region. From the colonial period to the present, local artisans shaped local clay, wood and metal into vessels for daily use. A few of these functional potteries that dot the South represent an unbroken line extending back to the colonial period. Traditions sometimes collapse from within and are revitalized from unexpected sources. The vitality of Southern craft would not be nationally acclaimed without the renewed interest in craft production and collecting, fostered by the craft revivals of the 1950s and 1980s. Before these revivals refocused national attention on languishing craft forms and techniques, the Penland School in North Carolina (est. 1925), the Southern Highland Craft Guild (est. 1929) and the Arrowmont School of Craft in Tennessee (est. 1943) were repositories of tradition and important technical knowledge.

Long before the craft revivals, the Arts and Crafts Movement exerted a significant regional influence through craftsmen in architecture, art pottery and everyday utilitarian objects. Many college and university art departments in the region were also strongly influenced by the idealism, the practical ties to industry and the abstract use of natural forms that define the Arts and Crafts Movement.

Believing in the integrity of the handmade in the crafting of everyday objects, the Arts and Crafts movement energized artisans and local craft traditions. One of the fundamental beliefs of the movement was the unity of the arts and the elevation of craft traditions to a position of equality with the fine arts. The Woodward brothers, Ellsworth and William, absorbed these new ideas at the Rhode Island School of Design and, in 1886, instituted an Arts and Crafts program at the newly created Newcomb College art department. The resulting program was one of the most important in the region and it created an art pottery that was prized more for its unique one-of-a-kind beauty than for its functional qualities. Today Newcomb pottery is recognized as one of the pinnacles of arts and crafts in the South.

George Ohr, the self-styled "Mad Potter of Biloxi," exemplifies the creative Southern eccentric who pursues a highly personal vision. Ohr's most fruitful decade, the years from 1895 to 1905, yielded pots of technical virtuosity and compositional daring. These pinched, folded, twisted and flowing pots of striking originality have strong bonds to Art Nouveau forms and the Arts and Crafts tradition, and have found an uncanny resonance with the forms of contemporary art and design. Since the rediscovery of Ohr in the late 1960s, his work has found a growing appreciation among a group of influential collectors, artists and architects, many of whom find personal inspiration for their own work in his daring art pottery.

Craft traditions have earned a permanent and distinctive place in contemporary culture. With the emergence of the Craft as Art Movement of the 1980s, many artists explored the boundaries of craft by merging craft-identified materials with the aesthetics of contemporary art. The Craft as Art movement today has its own unique canon and history, and continues to merge the changing boundaries of contemporary art and craft. Many artists that initially worked in craft traditions and materials, such as Stoney Lamar, Robyn Horn and Richard Jolley, are now seen as sculptors working in craft materials.

79

Stoney Lamar
Close Encounters #2, 2002
Bleached walnut and steel
86.3 × 38.1 × 12.7 cm
Gift of John and Robyn Horn
© 2002 Stoney Lamar

80
Anna Francis Simpson
Newcomb College Vase with Evening Sky,
Live Oaks, Moss, 1928
Ceramic
13.3 × 7.6 cm
Gift of the Roger Houston Ogden Collection

81
George Ohr
Bowl, 1895
Ceramic
7.6 × 12.7 cm
Gift of the Roger Houston Ogden Collection

82
George Ohr
Two-Handled Vase, 1895
Ceramic
12.0 × 12.0 cm
Gift of the Roger Houston Ogden Collection

83
Robyn Horn
Fractured Millstone, 2000
Jarrah Burl (Australia)
20.3 cm diameter
Gift of the Robert A. Katz Memorial Foundation
© 2000 Robyn Horn

84
Dan Finch
Urn, 2001
Clay
66 × 33 cm
Gift of the Artist, Dan Finch
© 2001 Dan Finch

86

Richard Jolley

Two with Birds, 1995

Hand-formed glass

91.4 × 43.1 × 35.5 cm

Gift of the Roger Houston Ogden Collection

© 1995 Richard Jolley

9 | Self-Taught, Outsider and Visionary Art

In the 1980s, self-taught artists gained increasing recognition and, by the end of the decade, were seen as an important current in contemporary art. The evolution and continued debate over the terminology used to describe the self-taught artists is indicative of the huge variety of work considered as self-taught art and its changing status within the mainstream art community. Originally considered a folk-art form, self-taught art has earned the additional labels of visionary, primitive and outsider art. Now recognized as a distinct genre of art, self-taught art has developed its own infrastructure of critics, dealers, collectors and museums. The scholarship of self-taught art has evolved beyond the search for a single overarching, all-inclusive label and has recently begun to explore the stylistic and regional differences that define the complexity of the genre.

Charles Hutson both defines and defies our ideas about self-taught artists. Hutson lived a full life as a scholar and writer before he retired and started sketching in 1905. He earned degrees from the University of South Carolina and subsequently fought in five Civil War battles, including Manassas and Yorktown. He taught literature, history and languages in seven Southern states, ending his career at Texas A & M University. After retiring to New Orleans, he began sketching the landscape of the Gulf Coast and New Orleans cityscapes.

Although she is often referred to as the black Grandma Moses, Clementine Hunter lived and worked in the sophisticated climate of Melrose Plantation in Natchitoches, Louisiana. As the cook in a thriving artists' colony, Clementine was in close contact with visiting artists and began painting with materials left behind by the New Orleans painter Alberta Kinsey. Her "memory paintings" of the daily life, people and history of Melrose have earned her both a popular local audience as well as national recognition.

George Andrews, known as "The Dot Man," exemplifies the expressive exuberance of the rural Southern tradition of self-taught art with his visionary will to decorate almost everything in sight with his distinctive dots, which transform everyday items into magical objects, while Thornton Dial and Bessie Harvey define the visionary strain of self-taught expressionism, also through the use of found and vernacular materials.

Previously considered outsiders, self-taught artists have now earned an influential place both within the contemporary art world and in the popular imagination.

87
George Andrews
Scramble Art, c.1989
Oil on canvas board
40.6 × 50.8 cm
Promised gift of the Benny Andrews Foundation
© 1989 Benny Andrews

88

Charles W. Hutson

Gulfport Palms, 1925

Oil on board

45.7 × 60.9 cm

Gift of the Hutson Family

© 1925 The Family of Charles W. Hutson

89
Theora Hamblett
Making Sorghum, 1964
Oil on canvas
60.9 × 101.6 cm
Gift of the Roger Houston Ogden Collection

90
Clementine Hunter
Panorama of Baptism on Cane River, 1945
Oil on window shade
91.4 × 182.8 cm
Gift of the Roger Houston Ogden Collection

91
Bessie Harvey
Chariot Ride, 1991
Mixed media
132 × 203.2 × 61 cm
Gift of the Roger Houston Ogden Collection
© 1991 Elizabeth Faye Dean

92

Thornton Dial, Sr.

Man Got It Made Sitting in the Shade, 1991

Braided rope on canvas mounted on wood

114.3 × 165.1 × 12.7 cm

Gift of the Roger Houston Ogden Collection

© 1991 Bill Arnett

94
Herbert Singleton
Leander Perez, 1992
Enamel paint on wood
50.8 × 152.4 cm
Gift of the Roger Houston Ogden Collection
© 1992 Herbert Singleton

95
Bennie Day
LSU vs Oklahoma, 1950
Mixed media
121.9 × 152.4 × 243.8 cm
Gift of the Day Family

Selected Southern Timeline

1884 William Woodward first teaches at Tulane University, New Orleans

1885 World's Industrial and Cotton Exposition, New Orleans

1886 H. Sophie Newcomb Memorial College established, Tulane University

1887 Ellsworth Woodward installed as head of the Art Department at newly founded Newcomb College

1889 Howard Memorial Library, designed by H. H. Richardson, opens on Lee Circle, New Orleans

1893 World's Columbian Exposition, Chicago, Illinois

1894 Valentine Richmond Museum founded (now the Valentine Richmond History Center)

1895 Newcomb Pottery, Newcomb College, established by William and Ellsworth Woodward, New Orleans (1895–1945)

1896 Plessy v. Ferguson, "separate, but equal"

1899 *The Awakening*, Kate Chopin (b. Katherine O'Flaherty, St. Louis, Missouri, 1850–1904)
First rights obtained to bottle Coca-Cola across most of the U.S. by attorneys from Chattanooga, Tennessee

1903 Orville Wright pilots the first motorized plane (built by Orville and his brother Wilbur) at Kitty Hawk beach, North Carolina

1904 Louisiana Purchase Exposition, St. Louis, Missouri

1909 W. C. Handy notates the first "blues" song, based on tunes from the cotton fields, levees, work camps and lonesome roads of the Mississippi Delta

1911 Isaac Delgado Museum in New Orleans is founded (now The New Orleans Museum of Art)
Mississippi Art Association founded (forerunner of Mississippi Museum of Art)

1913 The Armory Show in New York—International Exhibition of Modern Art—opens February 1913, at 69th Regiment Armory, introducing modern art to large audiences
Woodrow Wilson (b. Staunton, Virginia, 1856) is inaugurated as the 28th President of the United States (1913–1921)

1916 Brooks Memorial Art Gallery is founded in Memphis, Tennessee (now the Memphis Brooks Museum of Art)

1917 U.S. enters World War I (war ends 1918)

1918 George Ohr, "The Mad Potter of Biloxi," dies at age 61

1921 *The Double Dealer: A National Magazine from the South*, first published in New Orleans (1921–1926)
Will Henry Stevens begins teaching at Newcomb College, Tulane University, New Orleans, until his retirement in 1948

1922 Fugitive Group at Vanderbilt University, including Donald Davidson, John Crowe Ransom, Allen Tate and Robert Penn Warren, publishes *The Fugitive*, a poetry magazine
Southern States Art League (1922–1946) founded at Tulane University; Ellsworth Woodward president

1923 Penland Weavers (now the Penland School of Crafts) is established by Lucy Morgan in Penland, North Carolina
Lauren Rogers Museum of Art opens in Laurel, Mississippi

1924 The original Museum of Fine Arts in Houston, designed by William Ward Watkin, opens its doors to the public, becoming the first dedicated art museum building in Texas

1925 Louis Armstrong (b. New Orleans, Louisiana, 1901–1971) begins leading his own band, *The Hot Five*, in New York
Grand Ole Opry debuts on WSM Nashville radio

1926 David Donaldson writes "The Artist as Southerner" in the *Saturday Review*
Arts and Crafts School founded in New Orleans' French Quarter

1927 Great Mississippi River Flood
J. B. Speed Memorial Museum (now the J. B. Speed Art Museum) opens in Louisville, Kentucky (architect: Arthur Loomis)

1928 Shearwater Pottery established by Peter Anderson in Ocean Springs, Mississippi

1929 Southern Highland Craft Guild is organized in Asheville, North Carolina (chartered 1930)
Great Depression begins with Wall Street economic

collapse (October 29, 1929)

Look Homeward Angel, Thomas Wolfe (b. Asheville, North Carolina, 1900–1938)

1930 Montgomery Museum of Fine Arts (founded under Alabama Society of Fine Arts) opens in Montgomery, Alabama

The Duncan Phillips family turns its home into a modern art museum in Washington, D.C.

1931 *I'll Take My Stand*, Twelve Southerners (Agrarian Manifesto)

1933 Black Mountain College founded by John A. Rice, Black Mountain, North Carolina

Franklin Delano Roosevelt is inaugurated as the 32nd President of the United States (1933–1945), and will introduce New Deal, changing the South in important ways

Tennessee Valley Authority (TVA) is created by Congress to oversee development of dams, hydroelectric plants, waterways on the Tennessee River and its tributaries

Chicago World's Fair: *A Century of Progress*

1935 Works Progress Administration is organized

Southern Review founded, edited by Cleanth Brooks and Robert Penn Warren (1935–1942), Louisiana State University

1936 Dallas Museum of Art (est. 1903) opens new building, Texas State Centennial

Absalom, Absalom!, William Faulkner (b. New Albany, Mississippi, 1897–1962)

Jesse Owens, son of an Alabama sharecropper, wins four gold medals (track & field) in Berlin Summer Olympic Games

1937 Resettlement Administration is restructured and renamed the Farm Security Administration, employing photographers to document the lives of sharecroppers in the South and the migratory agricultural workers throughout the nation

Museum of Fine Arts opens in Little Rock, Arkansas (now the Arkansas Arts Center)

Lamar Dodd goes to Athens, Georgia and forms art department and museum (now the Georgia Museum of Art)

1938 John McCrady helps to found A New Southern Group, an association of artists

1939 New York World's Fair: *The World of Tomorrow*

Gone with the Wind, the film based on Margaret Mitchell's novel (1936), premieres in Atlanta, Georgia and later wins eight Oscars

1941 *Let Us Now Praise Famous Men*, Walker Evans and James Agee

National Gallery of Art, Smithsonian Institution opens (architect: John Russell Pope; East Wing completed 1978, architect: I. M. Pei)

Japanese attack Pearl Harbor; U.S. enters World War II (war ends 1945)

Modern television era begins when NBC and CBS begin broadcast television from New York

1942 John McCrady opens art school in New Orleans' French Quarter

Weatherspoon Art Gallery (Weatherspoon Museum of Art) opens in Greensboro, North Carolina

1944 Mechanical cotton picker is introduced

1945 Arrowmont School of Crafts is founded in Gatlinburg, Tennessee

1946 *Delta Wedding*, Eudora Welty (b. Jackson, Mississippi, 1909–2001)

All the King's Men, Robert Penn Warren (b. Guthrie, Kentucky, 1905–1989)

1947 *A Streetcar Named Desire*, Tennessee Williams (b. Columbus, Mississippi, 1911–1983), first presented in New York City

Jackie Robinson, baseball player (b. Cairo, Georgia, 1919–72), breaks Major League Baseball's color barrier, joining the Brooklyn Dodgers

1948 *Other Voices, Other Rooms*, Truman Capote (b. New Orleans, Louisiana, 1924–1984)

Louisiana Story, a film by Robert Flaherty with music by Virgil Thompson, is premiered in Abbeville, Louisiana, where the movie was filmed

Ray Charles cuts his first records, eventually creating a new style of pop music

1949 Hank Williams performs *Lovesick Blues* at the Grand Ole Opry

1950 William Faulkner (*Absalom, Absalom!, The Sound and the Fury*) wins the Nobel Prize in literature

1952 *Invisible Man*, Ralph Ellison (b. Oklahoma City, Oklahoma, 1914–1994)

Kentucky Fried Chicken franchise is begun by Colonel Harland Sanders in Corbin, Kentucky

1953 *A Good Man is Hard to Find,* Flannery O'Connor (b. Savannah, Georgia, 1925–1964)

Dwight David Eisenhower (b. Denison, Texas, 1890–1969) is inaugurated as the 34th President of the United States (1953–1961)

1954 Brown v. Board of Education of Topeka

Elvis Presley records *That's All Right Mama* and *Blue Moon Over Kentucky* at Sun Studios with Sam Phillips in Memphis

1955 Rosa Parks arrested in Montgomery, Alabama for

refusing to relinquish her seat for two white men

1956 Southeastern Center for Contemporary Art opens in Winston-Salem, North Carolina

Elvis Presley appears on the *Ed Sullivan Show* and releases *Heartbreak Hotel*

Fats Domino, a New Orleans native who exploded onto the rock 'n' roll scene a year earlier with his song *Ain't That a Shame*, puts five singles into the "Top 40"

1958 NASA (National Aeronautics Space Administration) is established, with facilities located across the South, including Houston and Cape Canaveral

Louisiana State University at New Orleans (now the University of New Orleans) opens to a student body of 1,498 students (now over 17,000 students)

1960 *American Painters of the South*, Corcoran Gallery, catalogue and exhibition

To Kill a Mockingbird, Harper Lee (b. Monroeville, Alabama, 1926) (Pulitzer Prize, 1961)

Wilma Rudolph, of St. Bethlehem, Tennessee, wins four gold medals (track & field) in the Rome Summer Olympic Games

Cummer Museum of Art and Gardens opens in Jacksonville, Florida

The Burden of Southern History, C. Vann Woodward (b. Arkansas, 1908)

The Movie Goer, Walker Percy (b. Birmingham, Alabama, 1916–1990)

1962 Wal-Mart (rated top company by *Fortune* magazine, 2002, 2003) is founded by Sam Walton in Rogers, Arkansas

1963 Lyndon Baines Johnson (b. near Johnson City, Texas, 1908–1973) is sworn in as the 36th President of the United States (1963–1969), following the assassination of John F. Kennedy in Dallas, Texas

Martin Luther King delivers his *I Have a Dream* speech to a crowd of 200,000 at Washington, D.C.'s Freedom March

Birmingham church bombing kills four black children

Bass Museum of Art is established in Miami Beach, Florida

1964 Civil Rights Act of 1964 is signed into law

Freedom Summer in Mississippi, during which three Civil Rights Workers are killed in Neshoba County

Martin Luther King receives the Nobel Peace Prize

Fine Arts Museum of the South (now the Mobile Museum of Art) opens in Mobile, Alabama

1965 U.S. enters Vietnam War (withdraws 1973)

The Renwick Gallery in Washington, D.C. becomes a component of the Smithsonian Institution

Lyndon Baines Johnson signs the Voting Rights Act of 1965 and introduces The Great Society

James Brown and the Famous Flames hit the "Top 10" of the pop charts with *Papa's Got a Brand New Bag*

1966 Kimbell Art Museum begins construction in Fort Worth, Texas (designed by Louis Kahn)

Southern Living magazine begins publication in Birmingham, Alabama

1967 Thurgood Marshall (b. Baltimore, Maryland, 1908–1993) is appointed the first African-American Supreme Court Justice.

1968 Martin Luther King, Jr. is assassinated at Lorraine Motel in Memphis, Tennessee

1969 Neil Armstrong, *Apollo 11*, is the first man to walk on the surface of the moon

Jim Henson (b. Greenville, Mississippi, 1936) introduces the Muppets and *Sesame Street*, a nationally televised children's show produced by Public Broadcasting Corporation

1971 Walt Disney World opens in Orlando, Florida

1972 George Wallace is shot, ending his bid for the Democratic nomination for President of the U.S.

1973 Secretariat wins the Kentucky Derby in record time, going on to win the Triple Crown

1975 Louisiana Superdome opens in New Orleans (architect: Arthur Q. Davis)

1976 *Roots*, Alex Haley (b. New York, resident of Tennessee 1921–1992)

William Eggleston's ground-breaking exhibition of color photography opens at the Museum of Modern Art in New York, accompanied by the publication of *William Eggleston's Guide*

New Orleans Contemporary Art Center opens in Warehouse District on Camp Street

America celebrates its Bicentennial

Two Centuries of Black American Art, David C. Driskel (b. Eatonton, Georgia, 1931)

1977 Elvis Presley dies at Graceland in Memphis

Center for the Study of Southern Culture is founded at University of Mississippi, Oxford

James Earl "Jimmy" Carter (b. Plains, Georgia 1924) is inaugurated as the 39th President (1977–1981) of the United States

Nexus Contemporary Art Center establishes the Nexus Press in Atlanta

1978 *Piazza d'Italia* erected in New Orleans; postmodern monument (architect: Charles Moore)

Mississippi Museum of Art opens in Jackson, Mississippi

1980 Ted Turner inaugurates Cable Network News (CNN) in

Atlanta, Georgia, the first channel in the world devoted exclusively to 24-hour news coverage

1982 Corcoran Gallery in Washington, D.C. presents *Black Folk Art in America, 1930–1980* and publishes book of the same name by Jane Livingston and John Beardsley

1983 Virginia Museum of Fine Arts presents exhibition *Painting in the South, 1564–1980* and catalogue with essays by Donald Kuspit, Jessie Poesch, Rick Stewart, Carolyn Weekly and Linda Simmons
High Museum of Art, founded in 1905, moves into its new Memorial Arts Building (architect: Richard Meier)
Art of the Old South: Painting, Sculpture, Architecture, and the Products of Craftsmen, 1560–1861, Jessie Poesch, Newcomb College

1984 *Art and Artists of the South: The Robert P. Coggins Collection*, Bruce W. Chambers, published at the time of the exhibition of the same name, organized by Columbia Museum of Art (Columbia, South Carolina)
Louisiana World's Exposition: *Water as the Source of Life*

1989 George Herbert Walker Bush (b. Milton, Massachusetts, 1942, resident of Texas) is inaugurated as the 41st President of the United States (1989–1993)
Encyclopedia of Southern Culture, edited by William Ferris and Charles Reagan Wilson, published by the Center for the Study of Southern Culture, University of Mississippi
Center for Documentary Studies founded at Duke University

1991 Walter Anderson Museum of Art opens in Ocean Springs, Mississippi (architect: Edward Pickard)

1992 Morris Museum of Art, first museum dedicated exclusively to the art of the American South, opens in Augusta, Georgia
Oxford American, a Southern literary magazine, first published in Oxford, Mississippi

1993 *A Lesson Before Dying*, Ernest Gaines (b. Pointe Coupee Parish, Louisiana, 1933)

William Jefferson Clinton (b. Hope, Arkansas, 1946) is inaugurated as the 42nd President of the United States (1993–2001)

1994 Cable Television's HGTV (Home & Garden Television), headquartered in Knoxville, Tennessee, is launched in 6.5 million homes, eventually reaching over 80 million homes

1995 American Visionary Art Museum opens in Baltimore, Maryland

1996 Samuel Mockbee founds Rural Studio, establishing architecture projects in Alabama's poorest county, Hale County, through Auburn University's School of Architecture.
Souls Grown Deep: African American Vernacular Art of the South, organized by William Arnett, Atlanta (exhibition accompanying the 1996 Olympics)
Art in the American South: Works from the Ogden Collection, Randolph Delehanty, published by LSU Press

1999 Mint Museum of Craft and Design opens in Charlotte, North Carolina
The Ogden Museum of Southern Art opens its Julia Street gallery in New Orleans (1999–2002)
Lance Armstrong (b. Austin, Texas, 1971) wins the first of four consecutive Tour de France titles

2001 George Walker Bush (b. New Haven, Connecticut, 1946, raised in Texas) is inaugurated as the 43rd President of the United States (2001–present)

2002 *The Quilts of Gee's Bend,* an exhibition of quilts created by African-American quilters from Alabama, opens at the Whitney Museum of American Art in New York; tour organized by the Museum of Fine Arts, Houston

2003 The Ogden Museum of Southern Art, University of New Orleans, opens in New Orleans, Louisiana, presenting *The Story of the South: Art and Culture 1890–2003* (architects: Errol Barron/Michael Toups Architects, Concordia APC)

Artists Biographies

Walter Inglis Anderson
b. 1903 New Orleans, Louisiana; d. 1965 Ocean Springs, Mississippi
Anderson is recognized for his drawings, watercolors and woodblock prints of the flora and fauna of the Mississippi Gulf Coast.

Benny Andrews
b. 1930 Plainview, Georgia; currently lives in Brooklyn, New York and Litchfield, Connecticut
Andrews is an artist and an art advocate whose narrative paintings and works in diverse media address social issues in the wider sphere of America and the South.

George Andrews
b. 1911 Plainview, Georgia; d. 1996 Athens, Georgia
Father of writer Raymond Andrews and painter Benny Andrews, self-taught artist George Andrews used exuberant decorative dots and patterns earning him the name "The Dot Man."

G. E. Arnold
b. 1929 Seminole, Oklahoma; d. 2003 New Orleans, Louisiana
Arnold was the Chief Photographer for the New Orleans *Times-Picayune* from 1961 to 1995.

Lynda Benglis
b. 1941 Lake Charles, Louisiana; currently lives in East Hampton, New York
Sculptor Benglis has worked in a variety of experimental media and styles, varying from minimalism to more direct forms.

Harold Harrington Betts
b. 1881 New York City; d. 1915 (place of death unknown)
Betts painted scenes that captured the daily life of America, especially in the South.

Willie Birch
b. 1942 in New Orleans, Louisiana; currently lives in New Orleans, Louisiana
After earning national recognition in New York City, Birch returned to New Orleans where he continues to explore issues of community and African-American identity through his sculptures and paintings.

Vincencia Blount
b. 1924 Miami, Florida; raised and lives in Atlanta, Georgia
Blount has worked as a pioneer in the development of modern art in Atlanta, Georgia.

Dusti Bongé
b. 1903, Biloxi, Mississippi; d. 1993 Biloxi, Mississippi
Bongé painted and drew the cottages and industrial buildings of the seafood industry in Biloxi and became recognized as a pioneering Southern Abstract Expressionist artist in the 1950s.

Lyle Bongé
b. 1929 Biloxi, Mississippi; currently lives in Biloxi, Mississippi
Son of artists Dusti and Archie Bongé; Lyle Bongé studied at Black Mountain College and is known for his black and white abstract photography, and his images of Mardi Gras.

Douglas Bourgeois
b. 1951 Gonzales, Louisiana; currently lives in Gonzales, Louisiana
Bourgeois is known for his Magical Realist paintings of icons of popular culture and imaginative fantasy.

Clyde Broadway
b. 1944 Scottsboro, Alabama; currently lives in Scottsboro, Alabama
Broadway draws from past and present to recast icons of Southern history and culture.

Fritz Bultman
b. 1919 New Orleans, Louisiana; d. 1985 Provincetown, Massachusetts
After studies in Europe and America, Bultman settled in New York City, where he became a member of the inner circle of Abstract Expressionist painters and sculptors.

William Christenberry
b. 1936, Tuscaloosa, Alabama; currently lives in Washington, D.C.
Painter, sculptor and photographer, Christenberry's work is inspired by the rural landscape and vernacular buildings of his native Alabama.

Christopher Clark
b. 1903 Quincy, Florida; d. unknown
Clark worked for the Federal Art Project and painted many works in the Regionalist style, including a mural in Radio City Music Hall in New York City.

Maude Schuyler Clay
b. 1953 Greenwood, Mississippi; currently lives in Sumner, Mississippi
Schuyler Clay is a photographer whose work documents the landscape of the Mississippi Delta and the broader South.

Clyde Connell
b. 1901 Belcher, Louisiana; d. 1998 Shreveport, Louisiana
Connell's work is inspired by the forms and textures of Northwestern Louisiana, and a lifelong interest in the people and nations of the world.

Ralston Crawford
b. 1906 St. Catherine's, Ontario; d. 1978 New Orleans, Louisiana
Crawford taught at Louisiana State University and developed an interest in the architecture, music and street life of New Orleans, which then became lifelong subjects and concerns.

Bess Dawson
b. 1915 Tchula, Mississippi; d. 1994 McComb, Mississippi
As one of the artists who comprised the Mississippi Summit Trio, Dawson's work is an early example of Abstract Expressionism in the South.

Arless Day
b. 1951, Baton Rouge, Louisiana; currently lives in Sarasota, Florida
Day's complex collages explore the way representation and illusion define place.

Bennie Day
b. 1918 Baton Rouge, Louisiana; d. 1995 Baton Rouge, Louisiana
Day was an architectural draftsman who carved and painted sports figures as a hobby. His panorama of the 1950 Sugar Bowl toured the South; he was the father of Arless Day.

Harry Anthony de Young
b. 1893 Chicago, Illinois; d. 1956 San Antonio, Texas
Painter de Young moved to Texas in 1928, where he organized an art school and became recognized as an important landscape artist.

Thornton Dial, Sr.
b. 1928 Emmel, Alabama; currently lives in Bessemer, Alabama
The expressionistic work of Dial bridges the gap between visionary self-taught art and the mainstream art world.

Alexander John Drysdale
b. 1870, Marietta, Georgia; d. 1934 New Orleans, Louisiana
Landscape painter Drysdale is known as a prolific artist of Tonalist and Impressionist-inspired landscapes, commonly including bayou scenes and New Orleans' City Park.

William Dunlap
b. 1944 Webster County, Mississippi; currently lives in McLean, Virginia and Coral Gables, Florida
Dunlap's work ranges from traditional landscapes to sculpture, performance and installation art, all inflected with a distinctive narrative quality.

Edward G. Eisenlohr
b. 1872 Cincinnati, Ohio; d. 1961 Dallas, Texas
Eisenlohr's paintings are influenced by the European Romantic tradition.

Walker Evans
b. 1903 St. Louis, Missouri; d. 1975 New Haven, Connecticut
Walker Evans photographed independently in the South and for the Farm Services Administration in the 1930s; he became one of the most important documentary photographers of the 20th century.

Dan Finch
b. 1946 Wilson, North Carolina; currently lives in Wilson, North Carolina
Finch, a potter, is known for the salt-glaze stoneware pottery of the longstanding tradition of Seagrove pottery in central North Carolina.

John Kelly Fitzpatrick
b. 1888 Kellyton, Alabama; d. 1953 Montgomery, Alabama
After serving in France in World War I and studying at the Académie Julian, Fitzpatrick returned to Alabama, became a leading artist in the state and remained there for the rest of his life.

Justin Forbes
b. 1967 Hollywood, California; currently lives in Modesto, California
Forbes, active in New Orleans in the 1990s, paints playful narrative works combining references from the history of art with a distinctive synthesis of diverse popular cultural sources.

Mitchell Gaudet
b. 1962 New Orleans, Louisiana; currently lives in New Orleans, Louisiana
Glass artist and teacher, Gaudet explores color and the sculptural possibilities of glass in his work.

Sam Gilliam
b. 1933 Tupelo, Mississippi; currently lives in Washington, D.C.

Gilliam is one of the foremost contemporary American Color Field painters, who works in a diverse range of materials including draped fabric.

Crawford Gillis
b. 1914 Selma, Alabama; d. unknown
Gillis was an Alabama Regionalist painter who worked in a variety of modernist styles after World War II.

Louis Graner
b. 1867 Barcelona, Spain; d. 1929 Spain
Spaniard Graner lived in New Orleans from 1914 through 1922, executing portraits, genre scenes and landscapes.

William Greiner
b. 1957 New Orleans, Louisiana; currently lives in Metairie, Louisiana
Greiner's color photographs explore the urban and suburban worlds of his native Louisiana.

Theora Hamblett
b. 1895 Paris, Mississippi; d. 1977 Oxford, Mississippi
Hamblett's paintings were inspired by her vivid memories and dreams of her life in rural Mississippi.

Bessie Harvey
b. 1929 Dallas, Georgia; d. 1994 Alcoa, Tennessee
Late in life, self-taught artist Bessie Harvey began making visionary figurative sculpture with found wood.

Sven August Knute Heldner
b. 1877 Vederslov, Sweden; d. 1952 New Orleans, Louisiana
After visiting New Orleans in 1923, Heldner relocated there along with his wife, Collette, and became a fixture of the Bohemian French Quarter.

Robyn Horn
b. 1951 Fort Smith, Arkansas; currently lives in Little Rock, Arkansas
Robyn Horn has earned national acclaim for her turned-wood sculptures. She is an important collector and crafts advocate.

Marie Atchinson Hull
b. 1890 Summit, Mississippi; d. 1980, Jackson, Mississippi
Hull studied in Europe before returning to Mississippi, where she painted portraits of the dispossessed sharecroppers and tenant farmers of the Mississippi Delta, and taught art for many years in Mississippi.

Nene Humphrey
b. 1947 Portage, Wisconsin; currently lives in Brooklyn, New York and Litchfield, Connecticut
Nene Humphrey's post-minimal experimental work has been exhibited at museums and galleries across the South. She is the wife of painter Benny Andrews and an accomplished art instructor.

Clementine Hunter
b. 1886 or 1887 Cloutierville, Louisiana; d. 1988 Natchitoches, Louisiana
Hunter worked as a cook at the artist colony at Melrose Plantation in Natchitoches before she started her "memory paintings." She went on to become one of the South's best-known self-taught artists.

Charles Hutson
b. 1840 McPhersonville, South Carolina; d. 1936 New Orleans, Louisiana
Hutson was an academic and scholar before he started painting and sketching in 1905 at age 65. He later became recognized for his Gulf Coast landscapes and New Orleans cityscapes.

Birney Imes
b. 1951 Columbus, Mississippi; currently lives in Columbus, Mississippi
Photographer Imes documents the rural life and passing order of his native Mississippi.

Richard Jolley
b. 1952 Wichita, Kansas; currently lives and works in Knoxville, Tennessee
Jolley's figurative glass redefines the boundaries between craft and sculpture.

Wolf Kahn
b. 1927 Stuttgart, Germany; currently lives in New York
Came to the United States in 1940. Worked at a studio in Louisiana in the 1950s, and has constantly revisited the South to paint and draw landscapes and architectural subjects.

Ida Kohlmeyer
b. 1912 New Orleans, Louisiana; d. 1997 New Orleans, Louisiana
Kohlmeyer became nationally recognized for her highly personal approach to abstract painting.

Jack Kotz
b. 1961 Des Moines, Iowa; currently lives in Santa Fe, New Mexico
Kotz was raised in Virginia and has worked as an architectural and documentary photographer. His book *Ms. Booth's Garden* looks at his grandmother's world in Mississippi.

Stoney Lamar
b. 1951, Alexandria, Louisiana; currently lives in Saluda, North Carolina
Lamar began working in turned wood and has steadily evolved a highly distinctive style of wood and metal sculpture, which blurs the traditional boundaries between art and craft.

Clarence John Laughlin
b. 1905 Lake Charles, Louisiana; d. 1985 New Orleans, Louisiana
Laughlin's photography was influenced by Symbolist theories of equivalency: that the visible world is symbolic of an invisible metaphysical order.

Ogle Winston Link
b. 1914 Brooklyn, New York; d. 2001 South Salem, New York
Photographer Link spent most of his career in Virginia documenting the last of the Norfolk and Western steam-engine trains.

John McCrady
b. 1911 Canton, Mississippi; d. 1968 New Orleans, Louisiana
McCrady was an important Regionalist painter who opened his own art school in the French Quarter of New Orleans.

Clarence Millet
b. 1897 Hahnville, Louisiana; d. 1959 New Orleans, Louisiana
Millet is known for his architectural paintings, genre scenes and Louisiana landscapes.

William Moreland
b. 1927 New Orleans, Louisiana; currently lives in New Orleans, Louisiana
Moreland is known for his abstract landscapes of the bayous of Southwestern Louisiana, and his career teaching at the University of Southwest Louisiana.

Elemore Morgan, Sr.
b. 1903 Baton Rouge, Louisiana; d. 1966 Baton Rouge, Louisiana
Morgan photographed traditional folk life and the growth of modern industry in Louisiana.

Elemore Morgan, Jr.
b. 1931 Baton Rouge, Louisiana; currently lives in Kaplan, Louisiana
Morgan, who taught at the University of Southwest Louisiana, paints panoramic landscapes of the prairies of Southwest Louisiana and urban scenes along the Mississippi River.

Jesús Bautista Moroles
b. 1950 Corpus Christi, Texas; currently lives in Rockport, Texas
Jesús Bautista Moroles continues the modern exploration of complex geometric shapes in stone.

David Rae Morris
b. 1959 Oxford, England; currently lives in New Orleans, Louisiana
Morris is a photojournalist and documentary photographer. His book *My Mississippi* explores contemporary Mississippi culture through photographs and the writings of the artist's father, Willie Morris.

Paul Ninas
b. 1903 Cape Girardeau, Missouri; d. 1964 New Orleans, Louisiana
Pioneering modern artist, Ninas traveled widely before settling in New Orleans in 1932, where he worked in a variety of modernist styles and was active in the Bohemian French Quarter.

George Ohr, Jr.
b. 1857 Biloxi, Mississippi; d. 1918 Biloxi, Mississippi
Ohr, the self-styled "Mad Potter of Biloxi," languished in obscurity until the rediscovery of his distinctive art pottery in the 1960s.

Robert Julian Onderdonk
b. 1882 San Antonio, Texas; d. 1922 San Antonio, Texas
Onderdonk was known for his colorful Impressionist-influenced Texas landscapes.

Clara Caffrey Pancoast
b. 1873 Lafayette, Louisiana; d. 1958 San Antonio, Texas
Landscape painter Pancoast captured the character of the unique Texas landscape.

Thomas Rankin
b. 1957 Louisville, Kentucky; lives in Durham, North Carolina
A photographer, filmmaker and folklorist, Rankin's work documents the vernacular culture of the rural South. He is also Director of the Center for Documentary Studies at Duke University.

Edward Rice
b. 1953 North Augusta, South Carolina; currently lives in
Augusta, Georgia
Rice's landscapes and meticulously detailed vernacular
architectural paintings are based upon sites in South Carolina
and Georgia.

Noel Rockmore
b. 1928 New York, New York; d. 1995 New Orleans, Louisiana
Rockmore painted the musicians and street life of New Orleans
with the Social Realist approach he practiced at the Art
Students League in his native New York.

Nellie Mae Rowe
b. 1900 Fayette County, Georgia; d. 1982 Vinings, Georgia
Rowe, a Georgia self-taught artist, is known for her colored
marker drawings and sculpture made with found objects.

Lulu King Saxon
b. circa 1855 Louisiana; d. 1927 New Orleans, Louisiana
Saxon's work shows the influence of the French landscape
tradition combined with a sense of subtle observation.

Adolph Robert Shulz
b. 1869 Delavan, Wisconsin; d. 1963 Brown County, Indiana
Shultz founded the Nashville Art Colony and painted tonalist
landscapes, many of them Florida scenes.

Ben Shahn
b. 1898 Kovno, Lithuania; d. 1969 New York, New York
Painter, photographer and graphic artist, Shahn photographed
extensively in the South for the Farm Security Administration
(FSA) during the Great Depression.

Kendall Shaw
b. 1924 New Orleans, Louisiana; currently lives in Brooklyn,
New York
Shaw gained national and international recognition for his
large, patterned, abstract paintings in the 1970s and early
1980s.

William Posey Silva
b. 1859 Savannah, Georgia; d. 1948 Carmel, California
Silva studied in America and Europe. He painted landscapes
throughout the South and was a founder of the Southern
States Art League.

Anna Frances Conner Simpson
b. 1880 New Orleans, Louisiana; d. 1930 New Orleans,
Louisiana
Simpson was one of the most celebrated decorators of
Newcomb pottery.

Herbert Singleton
b. 1945 New Orleans, Louisiana; currently lives in New
Orleans, Louisiana
Self-taught sculptor Singleton carves narrative sculpture that
addresses African-American social and political issues.

Alice Ravenel Huger Smith
b. 1876 Charleston, South Carolina; d. 1958 Charleston,
South Carolina
Smith was a leader in the rediscovery of Charleston's cultural
heritage. Her watercolors and prints of the swamps and
rice culture of the South Carolina low country were influenced
by the space and color of Japanese prints.

Keith Sonnier
b. 1941 Mamou, Louisiana; currently lives in New York, New
York
Sonnier's neon sculpture originally drew inspiration from the
neon of the nightclubs in rural Louisiana. He has become inter-
nationally celebrated for his sculptures and installations, many
of them permanent site-specific works in Europe.

Jack Spencer
b. 1951 Kosciusko, Mississippi; currently lives in Nashville,
Tennessee
Jack Spencer's photography captures the poetic side of the
people and places of the rural South.

Will Henry Stevens
b. 1881 Vevay, Indiana; d. 1949 Vevay, Indiana
Stevens taught at Newcomb College in New Orleans and
became one of the pioneers of modern art in the South.

Alexander Stolin
b. 1963 Kiev, Ukraine; currently lives in Madisonville, Louisiana
Stolin's realistic paintings and drawings capture the people and
places of south Louisiana.

Fred Trenchard
b. 1941 New Orleans, Louisiana; currently lives in New
Orleans, Louisiana and Haleiwa, Hawaii
Trenchard's paintings and drawings combine elements of

abstraction and realism to explore history, social issues and the natural world, as well as visionary architecture.

Helen Maria Turner
b. 1858 Louisville, Kentucky; d. 1958 New Orleans, Louisiana
Turner was trained in New York and was a member of the National Academy of Art. In 1926 she moved to New Orleans and painted interiors, flowers and portraits in a distinctive American Impressionist style.

Elizabeth O'Neill Verner
b. 1883 Charleston, South Carolina; d. 1979 Charleston, South Carolina
Verner studied in South Carolina, Europe and Japan, and became a preservationist and one of the important artists of the Charleston Renaissance.

Robert Warrens
b. 1933 Sheboygan, Wisconsin; currently lives in New Orleans, Louisiana
Warrens' imaginative narrative paintings explore the tension between humanity and the natural order.

Richard Wilt
b. 1889 Berlin, Germany; d. 1937 Ann Harbor, Michigan

Wilt's painting captures a period of accelerated change in the nation, particularly in the South. He utilized a style that looked nostalgically back at Regionalist painting to depict a subject that looked forward to an era that would reshape the greater culture of the South.

Theodore Fonville Winans
b. 1911 Mexico, Missouri; d. 1992 Baton Rouge, Louisiana
Winans photographed the distinctive people and the dramatic landscape of Southwestern Louisiana.

Ellsworth Woodward
b. 1861 Seekonk, Massachusetts; d. 1939, New Orleans, Louisiana
Woodward started the art program at Newcomb College in New Orleans and worked in a colorful style that synthesized many approaches prominent in American and European art at the turn of the 20th century.

William Woodward
b. 1859 Seekonk, Massachusetts; d. 1939 New Orleans, Louisiana
William, along with his brother Ellsworth, started the Newcomb Art Program in 1886. His work is an amalgam of turn-of-the-century American and European styles.

Compiled with the assistance of Jenny Finkel

Index of Artists

Numbers in bold refer to pages on which illustrations appear